Portrait of
SEATTLE

Portrait of America Series

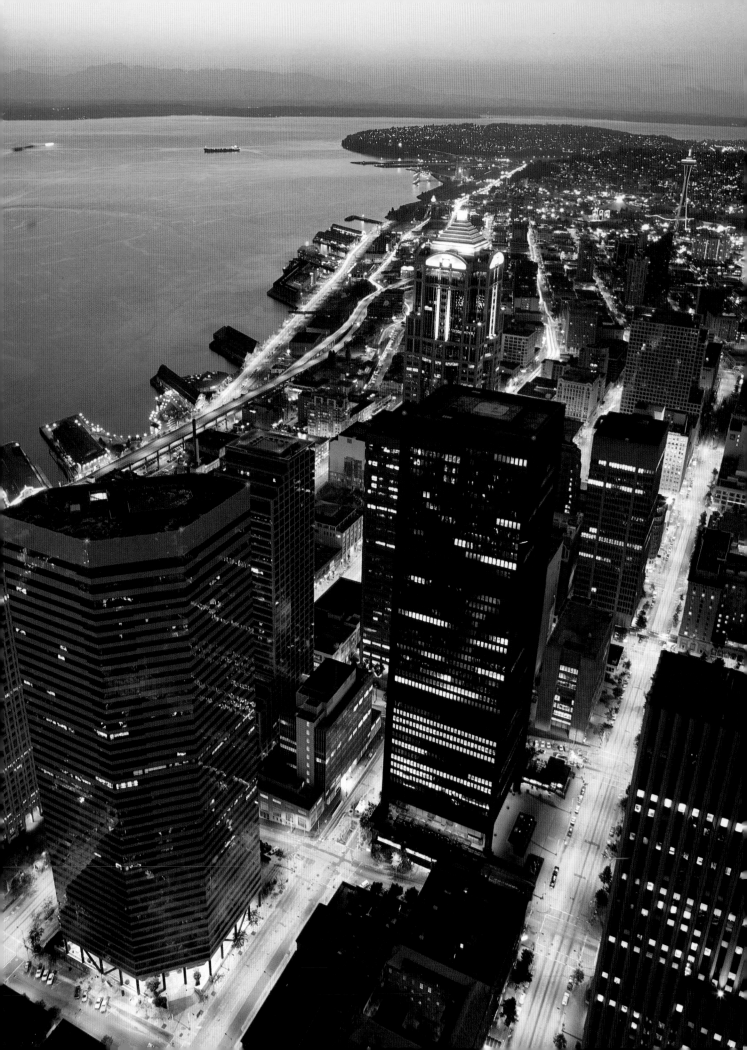

Portrait of
SEATTLE

Photography by Charles Krebs
Text by Timothy Egan

✖ GRAPHIC ARTS CENTER PUBLISHING®

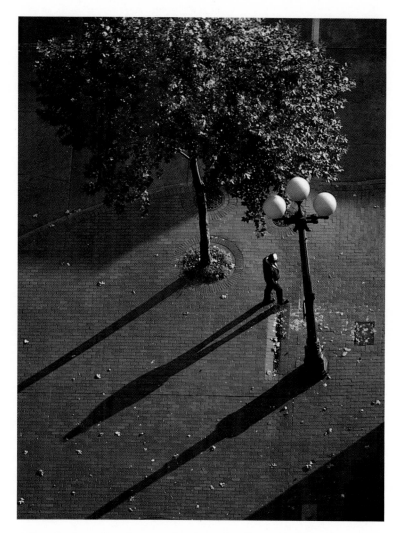

■ *Frontispiece:* Seattle sprawls along the shore of Elliott Bay when looking from the roof of the Columbia Seafirst Center. ■ *Above:* In the Pioneer Square Historical District, old cobblestones and lampposts regain their former glory. ■ *Right:* An aerial view of the Port of Seattle, the source of nearly one in eight jobs in King County.

International Standard Book Number 1-55868-001-2
Library of Congress catalog number 86-80096
© MCMLXXXIX by Graphic Arts Center Publishing Company
P.O. Box 10306 • Portland, Oregon 97296-0306 • 503/226-2402
President • Charles M. Hopkins
Editor-in-Chief • Douglas A. Pfeiffer
Associate Editor • Jean Andrews
Book Manufacturing • Lincoln & Allen Co.
Printed in the United States of America
Sixth Printing

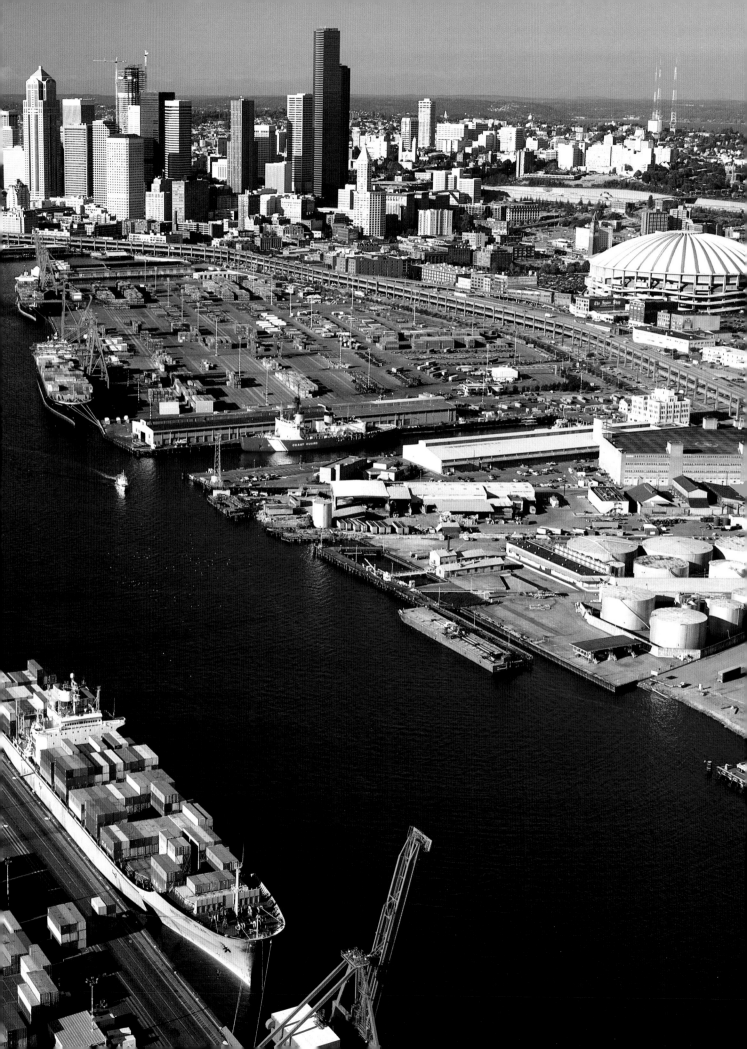

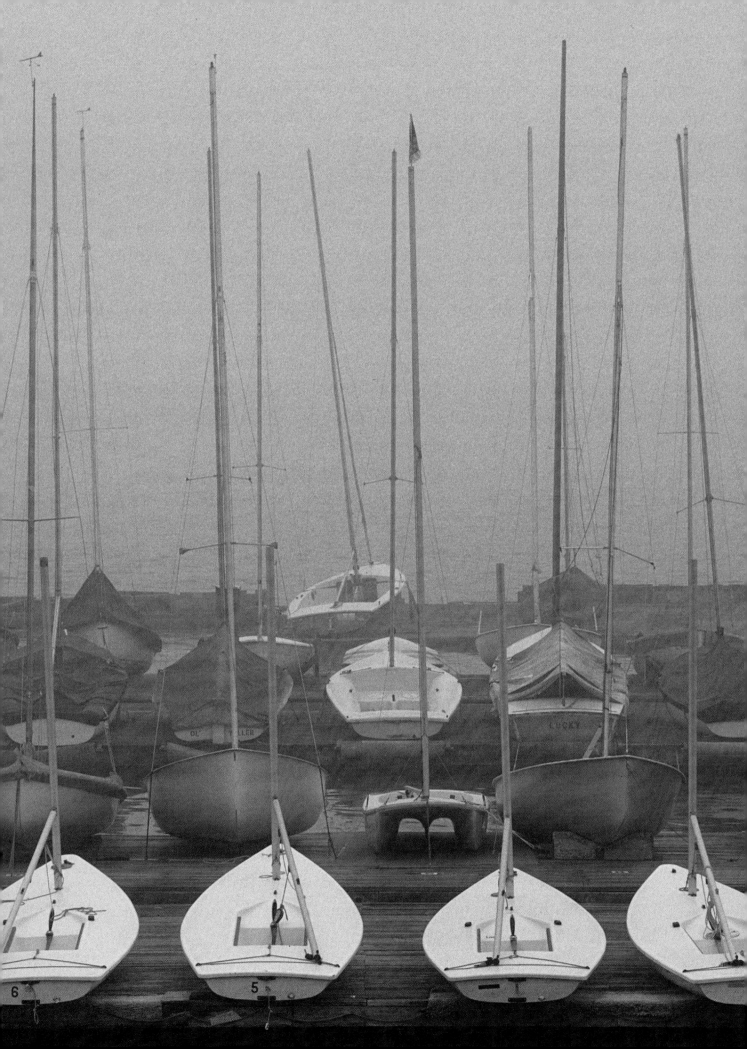

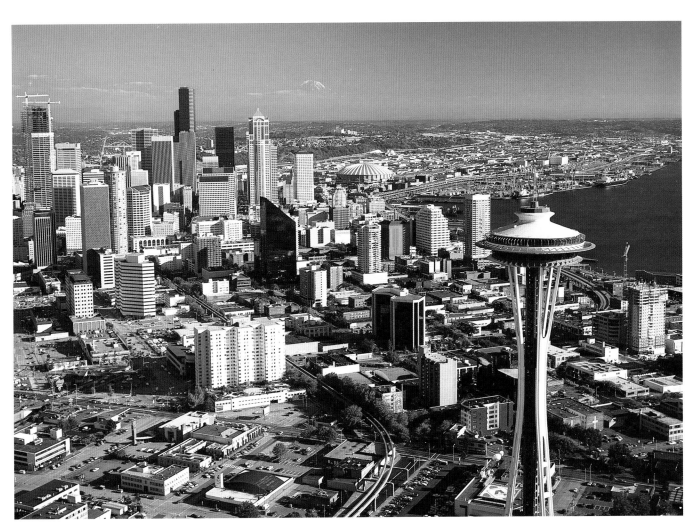

■ *Left:* Sailing is a year-round sport, but fog, like this cloak at Leschi Marina, can chill the most ambitious. ■ *Above:* Sun-drenched Seattle with Mount Rainier on the horizon remind one that "If you can see the mountain, it is *about* to rain; if you can't, it *is* raining. ■ *Overleaf:* With its high-rises and waterways, Seattle is a world trade center.

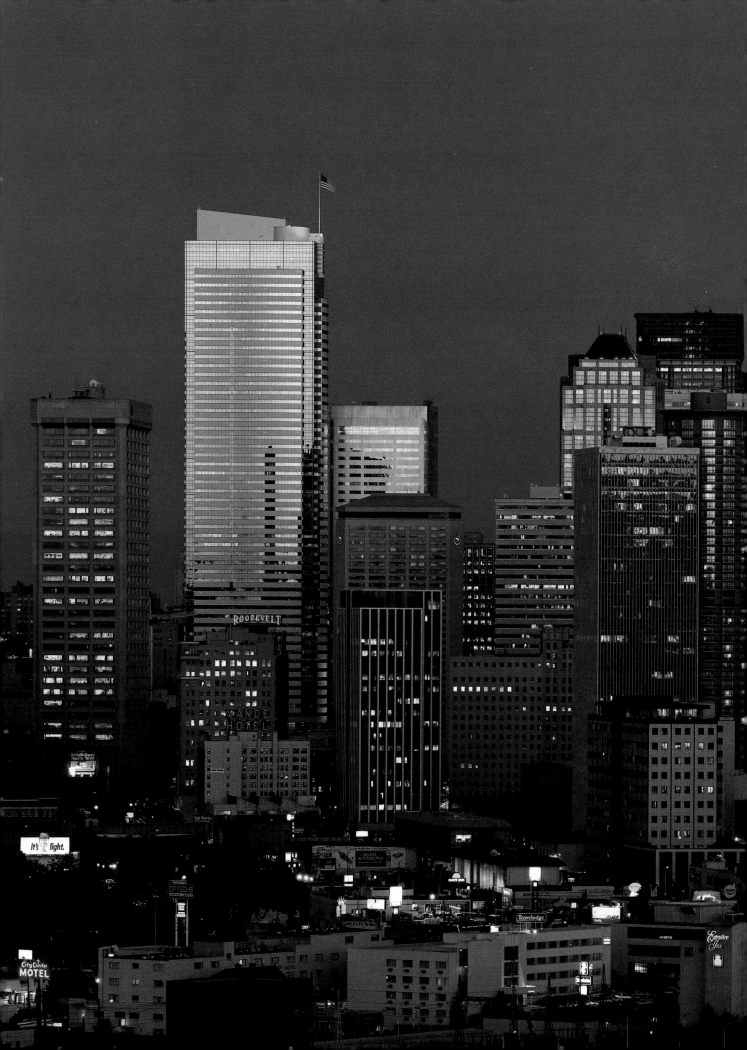

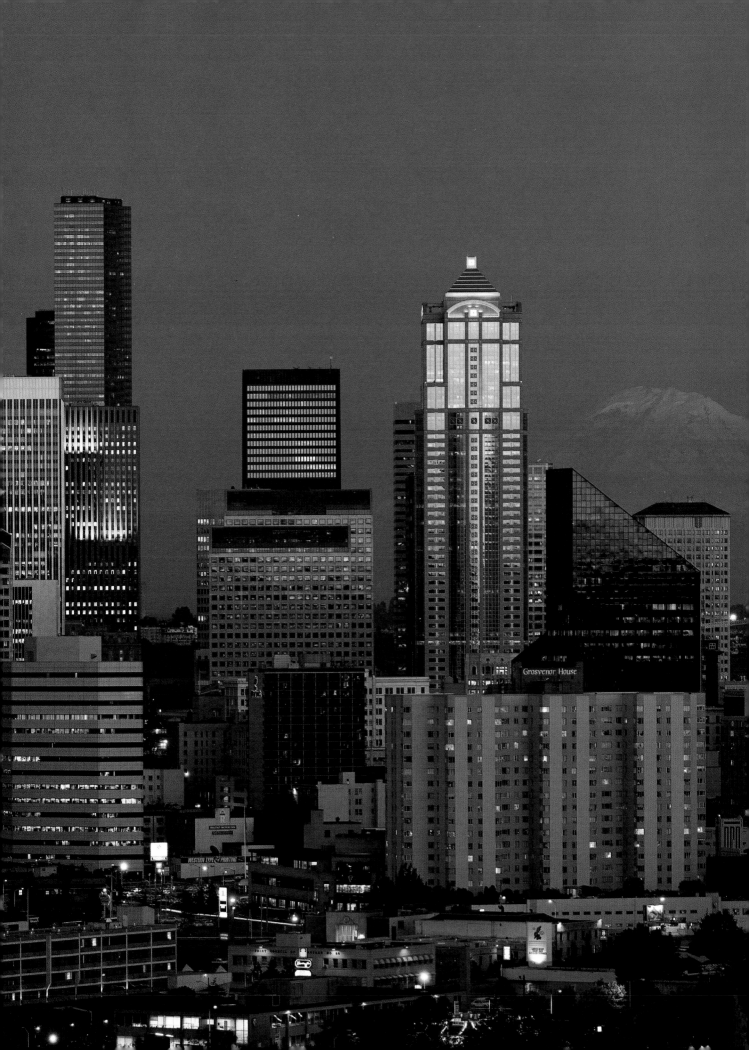

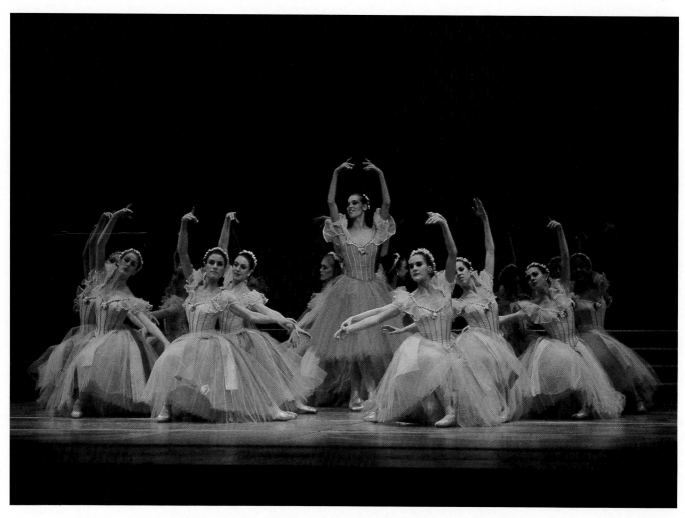

■ *Above: The Nutcracker,* staged annually by the Pacific Northwest Ballet, is a Christmas tradition. ■ *Right:* Nature's artwork, a rare Seattle snowstorm, redesigns the landscape at Occidental Park.

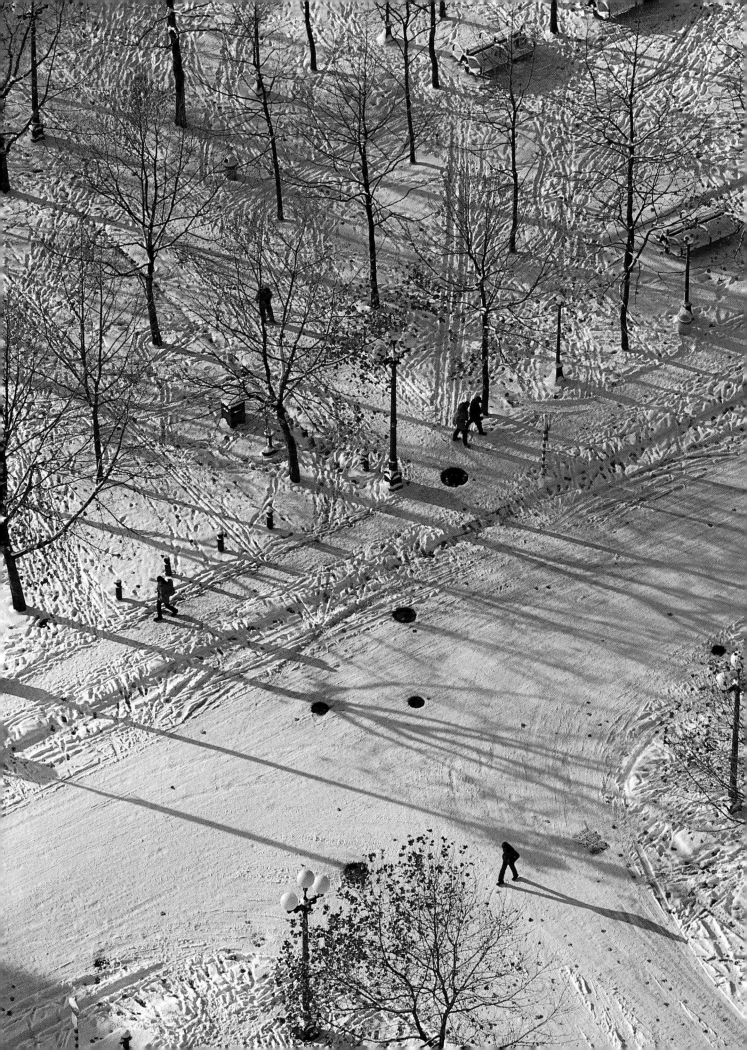

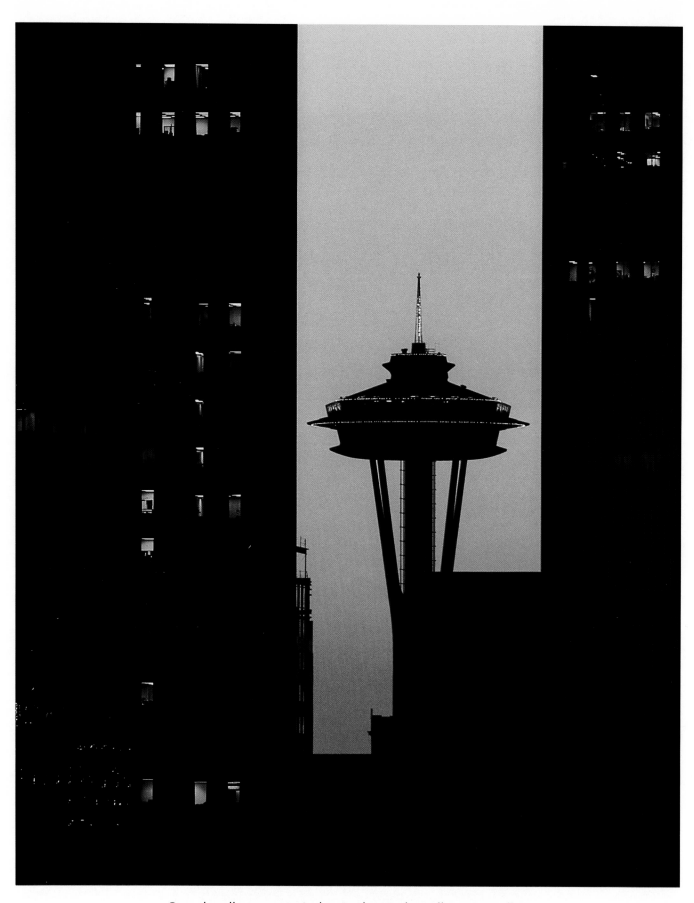

Once the tallest structure in the city, the 605-foot-tall Space Needle is now dwarfed by a cloud-scraping skyline. Built in 1962 for the World's Fair, the Needle's restaurant not only boasts fine cuisine, but also offers some of the city's most breathtaking vistas.

SEATTLE
by Timothy Egan

At two thousand feet, the plane dropped below the ceiling of clouds that was riding a Pacific breeze, and the Seattle native turned to his girlfriend sitting next to him. He whispered a single word—home—and for the first time in years, he felt it. His friend, long bullied by Lake Erie's winds, lived in Buffalo. He was born on Seattle's Queen Anne, an inner city slope crowded with urban charms, but he had been away for so long he felt as if he were descending on a new land, a pocket of paradise with enough room to take in a prodigal son.

By the time they landed, his girlfriend's mind was reeling from the visual overload: the glaciers of Mount Rainier, the islands of Puget Sound, the streams draining the west side of the Cascades into clear waters surrounded by almost a million people. Even then, the real surprise did not hit her until they drove into town. She could not take her eyes off the wind-shaped firs growing in roadside strips between the lanes of concrete.

"I don't believe this," she gushed. "Trees—right between the freeways—and nobody's stolen them."

Anyone who has ever lived in Seattle has a story about introducing a guest to the city. A first glance is like first love, unforgettable, perhaps a bit too romanticized. We tend to ignore the industrial jungle along the Duwamish and point instead to a local company with global reach, Boeing. We like the new buildings bumping against the low clouds downtown, but inevitably steer toward the city's first skyscraper, the Smith Tower. For nearly half a century, we point out, this landmark was the tallest building west of the Mississippi. We give in, after feigning disinterest, and take the visitor to Pike Place Market, called "the heart and soul of the city" by Mark Tobey, a native painter of world renown. And always, we have much to say about the punctuation mark on the southeastern skyline—Rainier.

The Indians, who remembered its violent past, mythologized it with the name "Tahoma," the mountain that is god. Captain George Vancouver, who sailed into Puget Sound in 1792 and renamed nearly everything of prominence after a friend, a distant cousin, or a superior back in England, was moved beyond his usual dry prose. He called the local environs and the 14,410-foot volcano "a landscape almost as enchantingly beautiful as the most elegant finished pleasure grounds of Europe." Two centuries later, Supreme Court Justice William Douglas remembered closing his eyes inside a New York subway and seeing the eternal snowfields of Rainier. As a boy, he had climbed its ridges and felt the cool breath of the mountain. First love.

Much of the geologic past of Seattle also can be traced to the volcano. Ragged glaciers, not unlike those that now cover nearly thirty-five square miles of Rainier, retreated from the Puget Sound lowland during the end of the last Ice Age about ten thousand years ago. The woolly mammoth romped around the Sound, nibbling on grass at the edge of the ice walls. The glaciers carved out hills and flattened valleys and raised the water level of the Sound three hundred feet. Then, about five thousand years ago, the top part of Rainier's summit broke away, which caused the massive Osceola Mudflow. This wall of wet earth, one of the largest which geologists have found, spread all the way to present day Kent. The flow left a fertile valley, today a home base for truck farmers selling their produce at the Pike Place Market, and it left a continual reminder of Rainier's power.

There is considerable evidence Native Americans were around when the last of the lowland ice melted away about 8,000 B.C. The artwork of numerous coast tribes suggests that, like those latter-day residents of Seattle, they too felt blessed. The climate was kind; they lived well, building longhouses, dining on salmon, berries, and game. Chief Sealth of the Suquamish Tribe supposedly saw Vancouver's ship, the *Discovery*, sail into Puget Sound. Sealth was just a kid then, and more than half a century would go by before he saw another historic vessel. It was 1851 when the pioneer schooner, *Exact*, tied up at Alki Point, and twelve white adults and an equal number of children disembarked. Sealth welcomed the Arthur Denny party, told them about local food sources and the quirks of the land, and watched them as they hacked four cabins out of the timber—unaware that within five years they would own his life-long stomping grounds. Property ownership was a concept for which his tribe did not have a word.

Sealth made friends with Doc Maynard, a middle-aged midwesterner on the run from a bad marriage and given to excessive drinking. When a territorial clerk in Olympia asked the name of the settlement, which had just been relocated at the mouth of the Duwamish after one miserable winter at Alki, the name Duwamps was offered. Maynard, fortunately, suggested Seattle—after his friend the chief, whose name Sealth was difficult for the newcomers to pronounce.

From most accounts, the chief died horrified at the thought that so many whites would speak his name long after his death—and burden his spirit. But he left an eloquent last speech, its poetic intent undiminished by the apparent polish of the translator. "Our dead never

forget the beautiful world that gave them being," said the old chief. "Every part of this soil is sacred in the estimation of my people. The very dust responds more lovingly to their footsteps than to yours, because it is rich with the dust of our ancestors."

Just one year after the town was named, Henry Yesler brought the muscle of a steam-powered sawmill to the struggling settlement. Seattle was carpeted with ancient firs, some as old as five hundred years and as tall as a fifteen-story building. The mill gobbled up timber that was scooted down the original skid road, and a booming log trade brought other settlers and a steady flow of ships to the deep, natural harbor at Elliott Bay. Many of the original pioneers were God-fearing working folk, but an equal number were not, and several historians contend that Seattle would not have become the premier city of the Northwest were it not for the first-rate bordello built next to Yesler's mill. Seattle's rowdy early history, a story of commerce and carnality, is well chronicled, particularly in Murray Morgan's timeless *Skid Road*.

One consistent theme emerging from a broad view of Seattle's history is the city's maverick streak. A strong aversion to conformity infused such diverse events as Arthur Denny's coup in obtaining a university from the territorial government in 1861, thirty years before anyone would have any use for it; the building of the Ship Canal in 1917; the opening of Bill Boeing's small biplane plant on Lake Union one year earlier; the Seattle General Strike of 1919 (the only general strike in American history); the World's Fair of 1962; and the park and transit projects that occurred with the Forward Thrust bonds of the same decade. Each of these undertakings was widely criticized, even derided. Each, in its way, fortified the growing city.

Almost from the start, the city grew at a rapid pace. The Gold Rush of 1897 brought in more prospective Seattle homeowners than prospectors. A brilliant public relations offensive convinced the ever-restless American that he could not go to Alaska without first spending most of his savings in Seattle. During this period, from 1890 to 1910, Seattle grew six times over. When the last of the original pioneers died in the early part of the twentieth century, the muddy little village on the shore of Elliott Bay was a brawny city with civic leaders ready to tear down hills and open new waterways.

The Gold Rush linked Seattle and Alaska in the public mind in a way that persists to this day. Seattle, of course, is much closer to San Francisco, 843 miles to the south, than it is to Anchorage, 2,484 miles to the north. Nonetheless, the latitude of Seattle, slightly above forty-seven degrees north, makes it the most northern of major American cities, which perhaps is a contributing factor to some of the Alaskan misconceptions. The city is even

farther north than Bangor, Maine, and about equal with Saint John's, Newfoundland. What this means to everyone besides armchair students of geography is that in the early summer the evening light lingers until almost ten o'clock. July and August usually average less than an inch of rainfall, and Seattle gardeners, whose numbers are legion, become much like their pampered plants, cherishing the sixteen hours of daylight, bursting with fresh energy.

The flip side is a dark December when the last light leaves around four o'clock, or a January when six inches of rain may fall in thirty days. Then, precipitation is best appreciated up on a mountain, like Rainier, site of the world's record for snowfall in a single winter—1,112 inches in 1972. Much has been made of the rain, but any Seattle school kid knows that the city's average of thirty-eight inches a year is less than all the major cities on the Eastern Seaboard. Some years, such as 1985, bring only twenty-five inches of rain. The recorded temperature extremes are easy to remember: zero for the low, and one hundred degrees for the high. For the record, it is not true that Mark Twain said, "The coldest winter I ever spent was a summer in Seattle." The city he named was San Francisco. On average, Seattle has 158 days per year when there is some form of measureable moisture that falls from the sky. While it is true that summers are generally dry, you can usually count on at least three weekends to be wet. Joel Connelly, a journalist who spends the warm months hiking in the Cascades, says the three sure bets for seasonal storms are the Memorial Day monsoon, the Fourth of July front, and the Labor Day low-pressure system.

Most people who live in Seattle use the weather to advantage—on the good days playing outdoors, on the bad days making good use of their proximity to a bone-dry desert, an ocean shore, or a rain forest. They travel in other ways, reading more books per capita than residents of any other American city, attending more films than all but a handful of other towns. (In contrast, their church-going is near the bottom of the national scale.)

And like it or not, the city continues to grow. A surge of newcomers has pushed the metropolitan area's population ahead of San Diego and just behind Minneapolis. Almost a third of all the people living in the state reside in the Seattle-Tacoma urban corridor.

Population growth, touted by the city's boosters since the days of mail-order real estate schemes and Gold Rush sloganeering, does not necessarily sit well with the average resident. Emmett Watson has had no trouble recruiting for his organization, Lesser Seattle, a somewhat tongue-in-cheek group whose members call themselves agents with a mission to keep newcomers out of Seattle. They sent pictures to relatives of bridges torn

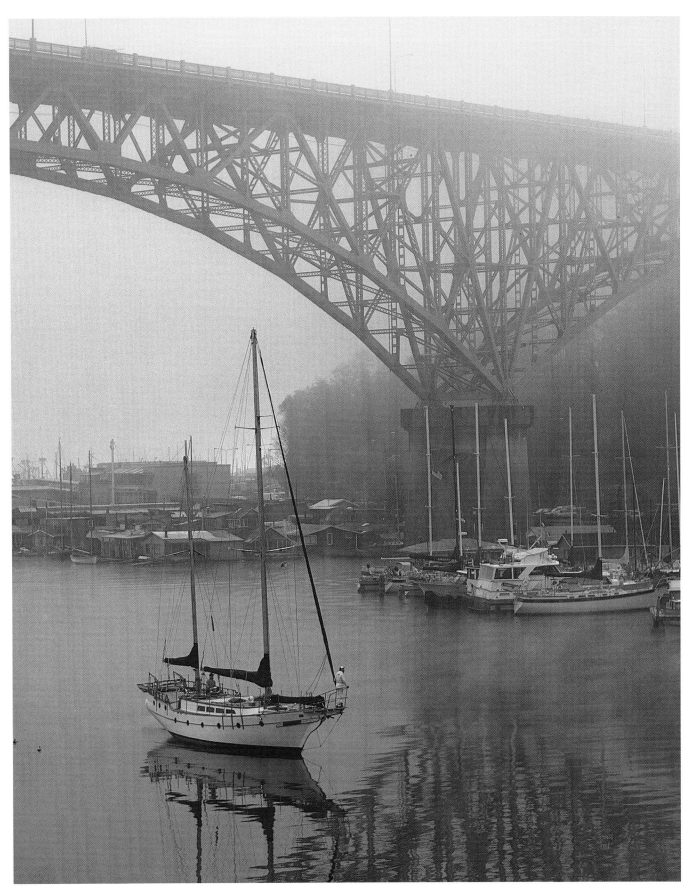

A sailboat under the Aurora Bridge waits to pass through the Lake Union Ship Canal. A city of bridges and boats, Seattle is spread over twelve hills and around three lakes. Puget Sound connects to inland freshwater via the Chittenden Locks and Salmon Bay.

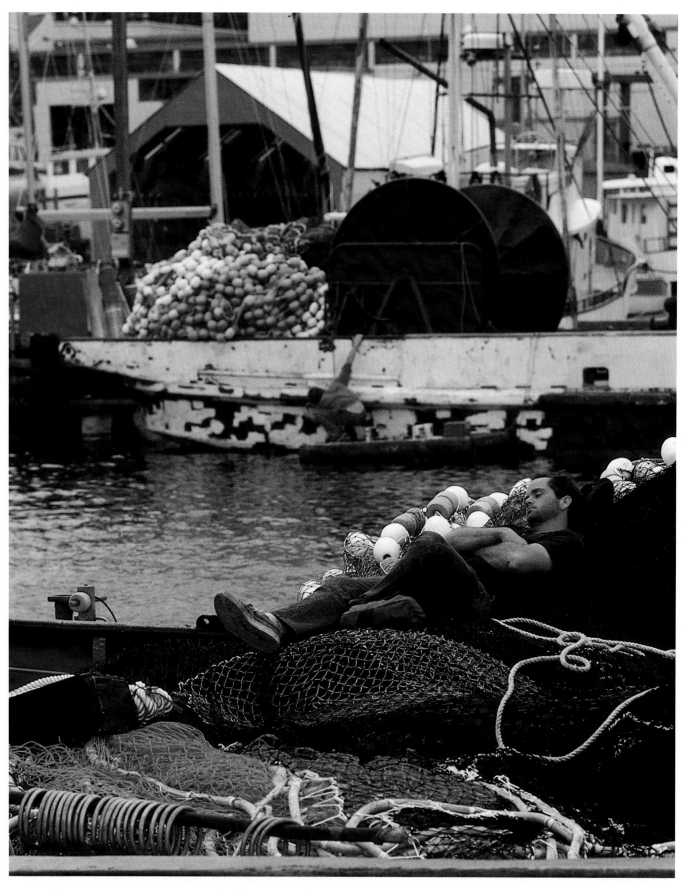

A snooze between chores forms a part of the natural rhythm at the Fisherman's Terminal in Ballard. Working the Pacific Ocean from Alaska to Mexico, the largest salmon and halibut fleet in the nation calls the Fisherman's Terminal home.

apart by storms and the gray city under the siege of a January downpour. A typical bumper sticker promotes "The Seattle Rain Festival—September to May."

Seattle has always cultivated a sharp sense of humor. Survivors of the Depression still remember Vic Meyers, the former nightclub owner and band leader who ran, successfully, for lieutenant governor on a platform of one-liners. Asked about daylight savings time during one of his campaigns, Meyers said he didn't believe in it. "Seattle," he explained, "should have two-four time, allegro." During the worst of the local recession of 1970, when Boeing laid off nearly two-thirds of its work force, a now legendary billboard placed near the city limits read: "Will the last person leaving Seattle turn out the lights." In fact, most out-of-work engineers stayed and helped diversify Seattle's economy.

Of course, no telling of the city's light side would be complete without a decent mention of Ivar Haglund, the mollusk mogul. Until his death in 1985, the walrus-faced old restaurateur was known to one and all by his first name. Seattle's favorite merchant jester—and later, its port commissioner—Ivar was given to two-hour work days and off-key renditions of his own songs. His favorite jingle was: "No longer the slave of ambition, I laugh at the world and its shams; and I think of my happy condition, surrounded by acres of clams."

POCKETS OF PARADISE

Those given to occasional outbursts of regional chauvinism do not like to admit it, but Seattle owes much of its reputation as a great city of public parks to New York. It is a hard truth, difficult for a native to accept, but no more difficult than the statistic the New Yorker must swallow: Manhattan gets more rainfall than Seattle. Two New York landmarks, Central Park and Coney Island, both American icons in their own way, had an indirect but undeniable influence on the young Northwest city during its park-building phase. From Central Park came competition; from Coney Island, inspiration.

First the competition. When Frederick Law Olmsted completed his design for Central Park in the 1860s, he was hailed as a genius and cities east and west requested his services. His two sons, the Olmsted brothers of Brookline, Massachusetts, carried on the family tradition. Seattle hired them in 1903 to bring together the greenbelts and patches of park scattered around a scruffy town, swollen with Gold Rush prosperity. The brothers had their father's masterpiece in mind and they went a step further. They plotted wilderness parks as chaotic as the land itself, connected by a series of elegant boulevards. At a time when city engineers were preparing to tear down hills and rip canals through the lake valleys,

the Olmsteds boldly determined to follow the unique contour of the land rather than fight it. Their grand idea was to allow continuous travel from park to park through tree-lined tunnels.

The plan, in part an elaboration of an earlier vision by a city official, was adopted in stages over the next twenty years but never quite completed as envisioned. Nonetheless, the Olmsted legacy dominates the park system, including the last stand of virgin timber at Seward Park; winding, wonderful Lake Washington Boulevard; the grand south entrance to the University of Washington; Ravenna Boulevard; Woodland Park's playful design; the boulevards on Magnolia and the north side of Capitol Hill; and the Victorian amenities of Volunteer Park, as well as a thousand little touches sometimes hidden by winter or neglect.

As inspiration, Coney Island helped make the parks palatable to city taxpayers. Why pay for raw land, many of the newcomers asked, when there is so much of it? The answer, in part, came with a series of amusement centers in private parks, which became some of the city's most beloved Sunday outing sites. To lure customers, the park operators introduced everything from casino gambling and caged bears at Leschi Park to the floating bandstands at Madison Park and the exotic rides and salt water bathing at Alki. When the city was able to purchase the popular private parks—or in some cases had them donated by overextended operators—their value was proven. Most of Seattle's major park purchases were made from 1900 to 1910, the most explosive growth period in its history. By the end of that first decade, a quarter of a million people lived in Seattle. More than fifty years would pass before any significant new park development began again.

But in the meantime, the Ship Canal was built. A dream of the pioneers, this enormous undertaking took seven years to complete. When the Chittenden Locks and Ship Canal finally opened in 1917, uniting Puget Sound with the great inland body of freshwater, a new shoreline was born. The lake's water level dropped a full nine feet, creating beaches and strips of greenbelt. The next time you pedal along Lake Washington Boulevard and stop for a snack on a strip of grass which used to be underwater, think of the laborers who dug the ditch.

Today, the city park system comprises 233 parks covering more than five thousand acres. The one that got away—Mercer Island—was recommended for purchase in 1910 and would have doubled total park acreage. Ah, well. If parks are indeed "the breathing lungs and beating hearts of great cities," as Mayor George Hall said a hundred years ago, Seattle is an Olympic athlete.

Periodically, a national magazine will massage the civic ego with a rave of Freeway Park, which is an oasis of

waterfalls straddling Interstate 5 in the heart of downtown, or 520-acre Discovery Park, the city's biggest and most primeval. Just as impressive are the quarter-acre miniparks, some with stunning views, or the fragile little garden parks, as delicate as a glass vase.

Seattle parks have personalities to match an individual's mood. The Washington Park Arboretum with its ideal canoe marshes, Japanese Tea Garden, and lanes of seasonal color is a perfect place to fall in love, renew an old love, or lose yourself in an impressionistic trance. By last count, there are more than five thousand different varieties of plant life in the Arboretum. Chances are, if it can live in a temperate climate, it is living well here.

Feeling blue? The brooding loner can find no better company than the weathered redwoods stooped along the nearly five miles of trail inside West Seattle's Lincoln Park. The trail follows a windswept bluff, drops to deep-shaded meadows, then opens to the seawall above Stony Beach. Here the salt air is original, untouched by the industrial scents or gastronomic diversions found along other parts of the city's waterfront. Covering 130 acres, this is one of the city's biggest parks and a good place to hide from the cosmopolis.

Those who desire different company can find a refuge in the Woodland Park Zoo or the Seattle Aquarium. The Zoo has been alternately vilified and glorified ever since the turn of the century, when the city purchased the site from an eccentric Englishman for $100,000. Like many of its inhabitants, the Zoo has never stopped evolving. After the Olmsteds added their own paths and animal playgrounds to the formal gardens left by Gus Phinney, various campaigns featuring broken-hearted lions or elephants housed in leaky sheds led to continual improvements. Today the Zoo is an award-winner and frequently named one of the top five in the country.

It does not take long to understand why. The African savanna provides everything but ancient man: zebras, springbok, hippos, giraffes, and their geographic kin roam the grasslands and frolic in the waterholes. There are no roofs. No cages. The city sounds are muffled. East Africa appears. Gorillas move lightly through their own mountain valley and tropical forest. At the indoor facility next to them, some primates were so happy Zoo officials had to give them birth control pills. Their home, with record in-captivity births, was beginning to resemble a maternity ward.

Intimacy under the sea is on display at the Seattle Aquarium. A visitor can go snout-to-snout with a black-tipped shark or play at the Touch-Tank, home of sea stars, featherduster worms, and sea anemones. The lasting value of the Aquarium, however, is the view it offers of a life cycle largely invisible yet crucial to the city. Most of what goes on in Puget Sound is hidden below its surface.

The Aquarium, especially its Underwater Dome, drops the landbound human in the middle of the age-old struggle between predator and prey. It is impossible to look on Elliot Bay in the same way afterwards.

Back among the bipeds on roller skates, the people parks of Green Lake, Alki, Volunteer, and Golden Gardens provide endless varieties of the human species at play. Volunteer Park offers a Gothic water tower, a lush garden conservatory, an outdoor amphitheater and has been aptly called, "The best free view in town." Olympic sunsets, with the arches of the Pacific Science Center glowing in the foreground, are legendary.

In summer, Alki Beach returns to its Coney Island roots. The sun-starved are always out in force, and hot-rodders and hamburger vendors compete for the attention of those in search of the body beautiful. Market reports confirm what many a native has long known: per capita, people in Seattle buy more suntan lotion than do residents of any other city in the nation, and they are not far behind the country's leading purchasers of sunglasses. Perhaps the tools of the sun trade are lost between nice days. During the warm months, Golden Gardens is much like Alki—full of swimmers defying the old maxim that a human being can only last about twenty minutes in the numbing waters of the Sound. A dip, even on days when the mercury dances around ninety degrees, is a bracing experience, an antidote to siesta sleepiness. In winter, a Golden Gardens stroller can feel the sting of the wind, watch the herons swoop, and imagine the city before the Denny party arrived.

Green Lake. Ah, Green Lake. Colored by the late-summer algae, the city's favorite all-purpose park is a north Seattle jewel created by glaciers from the last Ice Age. A sawmill used to slice timber on the northeast shore. A century ago, mom and dad packed a lunch and took a long day's hike to Green Lake. If they were lucky, they might stumble upon a deer or the occasional bear still roaming the fringe of the frontier town. By 1905, Green Lake had become part of the Olmsteds' master plan and in the following years managed to survive popularity and the serious suggestion of one civic leader that it be filled with dirt and leveled into a golf course. The loop around the lake is 2.8 miles, a course some people can run in under thirteen minutes. Most do it in about twenty-three. Diversions abound any time of year: skaters, bikers, windsurfers, and joggers pushing baby strollers. Even wildlife has a special spot: an island game reserve just south of the Bathhouse Theatre.

A jogging trail and bike path connect Green Lake to Ravenna Park, just north of the University of Washington. Ravenna Park, which was named by an early real estate promoter for a town in Italy, used to be famous for its ancient trees, some dating back to the Middle Ages. A

Lake Union offers a quick escape from the residential west slope of
Seattle's Capitol Hill, where view apartments are snuggled next to
refurbished mansions—all overlooking Lake Union.

One of Seattle's oldest and loveliest neighborhoods, Queen Anne Hill is known for its heart-pumping inclines and breathtaking views of Lake Union, the Seattle Center, and the city's skyscape.

creek runs through a ravine in the park, and the dark, wild-forest floor is perfect for the kind of growth usually found in an Olympic Peninsula rain forest. But what one arm of nature provided, the other took away; lightning kept striking down the oldest of the trees, thwarting a plan to preserve the grove as a tourist site. City officials were worried about safety so the last of the tall trees at Ravenna Park were ordered cut down.

Up high, out of the deep shadows, Seattle's smaller parks give the public a chance to enjoy regal property for less than a pauper's price. Kerry Park is a cozy aerie set amid the old mansions of Queen Anne Hill on West Highland Drive. Kobe Terrace, with its flowering cherry trees and its four-ton stone lantern from Japan, lines up the visitor for a sweeping view of the Duwamish Valley. Denny Blaine is a half-acre swimming hole bordered by million-dollar Lake Washington homes.

Faced with a dearth of available property in recent years, Seattle has reached into the creative well for ideas to keep the park system growing. By recycling neglected land, the city has transformed old dumps and weed-choked eyesores into parks and restful urban retreats. A sprawling parking lot in Pioneer Square was lined with trees and cobblestoned, and *Voilá!* Occidental Park now thrives in the heart of the historical district. Genesee Park, a favorite spot for soccer games and hydroplane racing fans during one mad week in August, was built over a landfill. The Army base in Magnolia shed its military trappings and was reborn as Discovery Park, a haven for herons, racoons, and, on one occasion, a cougar dubbed D.B.; Navy acreage at Sandpoint became Magnuson Park. Waterfront Park transformed a soggy site at Pier 59, and Myrtle Edwards did the same for an area next to the railroad tracks running north of the Aquarium. Both parks were made possible by a program entitled, "Forward Thrust," which led in the 1960s to the biggest expansion of the park system since days of the Olmsted brothers.

The most imaginative of the new additions is the Gas Works Park. Converted from a noxious gas plant to a nationally praised playground, Gas Works is now the favorite place in town to fly a kite. Or several kites. Viewed from the sundial atop the man-made mound, downtown shines across Lake Union. The park's toxic ghosts caused an environmental scare a few years back, but the former industrial site was given the okay after re-sodding the site and posting signs which read: "Please do not eat the dirt."

The ultimate recycling suggestion, made years ago in jest, no doubt, is indicative of the prevailing attitude. "Like many a native," wrote historian Stewart Holbrook, "I am privately of the opinion that this entire region should be set aside as one great park."

THE CENTER OF ATTENTION

They started pouring concrete into a triangular pit at the foot of Queen Anne Hill in May 1961. The neighborhood was nothing special: a few shabby storefronts, some homes in need of paint, a couple of sailor bars with 6 a.m. happy hours. By the time they were done, history's longest continuous cement pour had swooshed by—467 truckloads in all—and Seattle had an instant landmark. Thus was born the Space Needle, a star that graced the cover of *Life Magazine* twice in one year.

Slender, graceful, unique, the Needle was a hit beyond the wildest dreams of the group of scrappy Seattle planners trying to organize a world's fair around a vague scientific theme. Observers say Eddie Carlson, president of the fair commission, broke down in tears as he saw the concrete gush into place. After all, it was Eddie who first sketched a rough outline of the Space Needle on a cocktail napkin. Victor Steinbrueck was brought in for design work, adding class and tradition to the shoestring Needle budget of $4.5 million. Suddenly, it looked as if they might pull off the World's Fair. And they did, in grand style. The Century 21 Exposition drew almost ten million visitors between April and October 1962.

John Glenn, a man of the right stuff, came to talk about the space exhibits, as did his colleague in exploration, Russian cosmonaut Gherman Titov. Richard Nixon posed in front of the Needle. Robert Kennedy tried to keep track of his ever-expanding brood. Royalty was well represented, from the ill-fated Shah of Iran to England's Prince Phillip, who endeared himself with a quote about the joys of rain: "Let cats and lizards rejoice in basking in ever-lasting sunshine . . . mists and drizzles and even occasional light rains make sunshine all the more welcome and constitute the proper environment of man."

That most American form of royalty, the celebrity, also showed up. Elvis Presley, just out of the Army and trying to live up to his name as the King of Rock and Roll, used the fairgrounds as a backdrop for one of his most forgettable films, *Meet Me At the World's Fair.* Later, when the Fair was over, Warren Beatty poked around the Needle as the star of the psychological thriller, *The Parallax View.* The Needle, as they say in show business, had legs—true staying power.

Now the main draw of the seventy-four-acre Seattle Center, the Space Needle may be illuminated in a brilliant UFO display, it may host a giant inflatable crab dubbed "Louie" by the locals, or it may serve as the favorite sunset dinner site for out-of-town guests. Just as the Alaskan-Yukon-Pacific Exposition of 1909 led to an explosion of culture and growth at the University of Washington, the 1962 Fair hotwired Seattle in ways that are still being felt.

After the Fair was over, successful campaigns championed new parks, road and transportation improvements, clean water, and—the big plum for sports fans—the Kingdome. Before long, Seattle had a trio of prominent professional sports teams as well as several new cultural diamonds. All because of the Fair? No. But the glittery new exhibits of 1962 showed Seattle the way.

In retrospect, many of the science displays and even some of the predictions—floating cars, a glass dome covering downtown—may seem a little silly, and most of the permanent structures still look, well . . . futuristic. But the Monorail, an elevated train which whisks passengers from the Center to downtown in ninety seconds; the Needle; and the white Gothic arches in front of the Pacific Science Center have become Seattle symbols.

Most world fairs close down before creditors catch up with the operators. Seattle's fair made a small profit, a distinction that is still the envy of urban dreamers around the world. But it is a minor crime to define the Fair's success in bottom-line terms. Its legacy is not only a city cultural center, used year-round by sports fans and opera buffs, but a tourist mecca that is Seattle's number one visitor attraction. The Pacific Science Center, for example, is never without company, even on the dreariest winter day. Some come just to stare at the arches and throw pennies in the fountain, both Minoru Yamasaki creations. He drew the 110-story twin towers of New York's World Trade Center, but few in Seattle would trade King Kong's one-time hangout for the pleasing touches of the Center's arches. A scientific playhouse awaits the visitor in five buildings, each with exhibits designed to be "hands-on" experiences. One can step inside the miniature mouth of a volcano, start a small mudflow, be dazzled by optical illusions, defy gravity, or walk among life-sized dinosaurs. The laser light show at the Space-arium Theater is the astral equivalent of the Aquarium's spectacular underwater performances.

Another permanent structure, the Coliseum, helped to bring major league sports to Seattle. The Sonics began their playing days there, moved on to a mostly unhappy residency at the Kingdome, then came back home. Because of its unique design—the roof bends and flexes in nasty weather—the Coliseum contributed a footnote to sports history when a small leak during one Sonics game in 1986 caused the only pro-basketball rain-out. The Beatles and Bruce Springsteen have played at the Coliseum, as have science fiction buffs, home computer shows, the Rolling Stones, and the kings and queens of country, soul, and gospel music.

A becalming antidote to a rock show is the International Fountain. Designed in the shape of a sunflower, the fountain's 217 nozzles are rigged to a computer program, and the result is a flow of classical music and water. People who began a tour of the Seattle Center with ambitious plans have seen their day dribble away in hours of soothing diversion. Kids love to play near the sprays and a favorite trick is to figure out the timing of the nozzles and dodge the bursts of water. Parents do not always appreciate the hijinks. But then, kids do not always understand the dance steps of the stylish partners on display at Center House. One day, music from the Jazz Age whirls couples around the wooden floor. Another day, the Big Band Era is played out, and oh, how the wartime romance stories start to flow with the toot of the trumpet. For many, a night of dancing on the floor at the Center House is a tumble back in time.

The question, "What are we doing this weekend?" was not always easy to answer before the culture growth that came to the Center after the Fair. Now the more likely question is, "How do we fit it all in?" The Opera House became home to the Pacific Northwest Ballet Company, the Seattle Symphony, and the Seattle Opera, including the widely hailed cycles of Wagner's *Ring*. A stunning addition, the Bagley Wright Theatre joined the Opera House in 1983. Praised for its sleek design and named for one of the city's driving artistic boosters, the modern stage is home to the Seattle Repertory Theatre, known as The Rep, which presents six plays a season.

Culture on a more populist level sweeps in with the annual arrival of several major festivals. Best-attended is the four-day Labor Day fest, Bumbershoot, named for the British word for umbrella, a tool which most Seattle residents prefer to ignore. Sponsored by the city, the Bumbershoot is food of the world, dancing in the grass, wacky go-cart races, and lofty musical arrangements, along with the craftspeople who emerge from months of unseen labor with their artwork in full blossom and a story to go with each sale. The celebration continues ancient tradition, for the Center was once the site of Indian potlatch festivals. Here, centuries ago, tribal chiefs held gift-giving exchanges. Now, if you look with the mind's eye and listen, you can feel the resonance of the years on the landscaped grounds.

THE FRONTIERS OF CULTURE

A visitor was planning to attend the Seattle Symphony one night in early spring, not sure what to expect. She dressed in elegant evening style, as was customary in her native Boston. Her hosts treated her to dinner nearby, then they strolled into the Opera House for the show. The performance was first-rate, a sumptuous classical offering. She was impressed. Equally impressed was a man sitting not far from her. She did not notice him until the performance was over, then she saw him rise, slip a down vest over his plaid shirt, and exit. She smiled. It

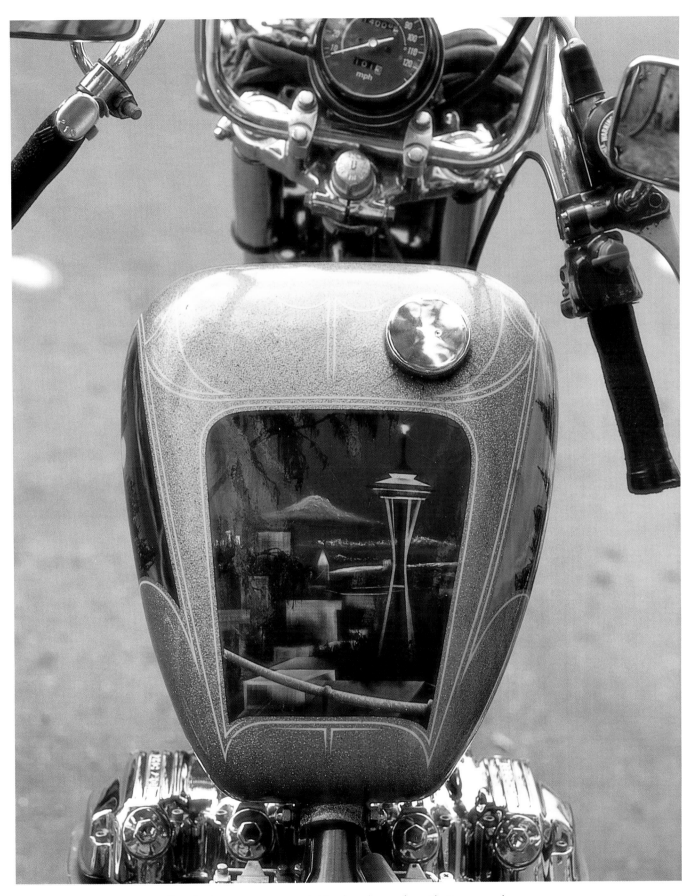

Seattle has numerous neighborhoods, each with its own charm, history, and character. This custom-painted motorcycle is parked in the Fremont District's lively commercial section.

In Ballard, Norwegian Independence Day rivals the Fourth of July. Scandinavians in this close-knit neighborhood depend on the sea for sustenance and on the annual parade for festive relief. Lutefisk and pastries are the favored foods during the May 17 celebration.

struck her as the essence of Northwest style: a sun-burned outdoorsman coming in from the elements to listen to Mozart.

While many Seattle natives would argue that a back-packer who appreciates ballet is the homegrown style, long-suffering culture promoters have spent years over-coming a backwoods image. Even while the arts are thriving and the city has gained a reputation as one of the nation's best theater towns, even as Seattle continues to bathe in international attention for daring dance shows and original stagings of classic operas, there is lingering insecurity. That insecurity can be traced to a famous broadside by Sir Thomas Beecham, a colorful British conductor who visited Seattle in 1948 at the invitation of citizens who hoped to upgrade the local symphony.

At the time, you could not buy liquor by the drink in any of the bare handful of respectable restaurants. There was no opera, no dance to speak of. Theater was some-thing for the rich to pursue in their spare time. Mark Tobey was on his way to world recognition, but few in the city knew what to make of him and his obsession with the Pike Place Market. Sir Thomas surveyed this arid cultural landscape and said, "If I were a member of the community, I really should get weary of being looked upon as a sort of aesthetic dustbin."

The insult was never forgotten. In the next fifteen years, the cultural climate altered so dramatically that Sir Thomas did not recognize the city on a return visit. For one thing, you could enjoy a cocktail with dinner at the new four-star restaurants that appeared after changes were made in the liquor laws.

Many credit the World's Fair with bringing big league sensibilities and sophistication to the city—or at least a desire for same. In came the Opera House, the Play house, the Coliseum, and, in the early 1980s, the Bagley Wright Theatre. And around town, smaller, more risky theaters sprang up and—surprise—most of them sur-vived. Today, the Seattle Repertory Theatre runs second in season ticketholders to the Huskies and Seahawks. Off and on, the city has supported almost a dozen Equity theaters—more than any city but New York. That does not count the smaller, quality theaters which are spread around the different neighborhoods. In one recent year, three of *Time* magazine's ten outstanding achievements in theater were linked to Seattle.

The five main professional theaters—The Rep, A Con-temporary Theatre, Intiman, Empty Space, Children's—support up to two hundred working actors. Each of the theaters caters to a slightly different crowd, from the traditional to the more avantgarde. The Rep, housed in the Bagley Wright Theatre, puts six major productions on the boards each season. Among smaller theaters, the Paul Robeson has conducted original productions with

ethnic themes for several seasons, while the Pioneer Square Theater is home for Seattle's longest running and most successful play—*Angry Housewives*. In a twist to tweak the sensibilities of Sir Thomas, a staging of the Seattle play was arranged in London in 1986. New thea-ter usually goes the other way. While new stages were basking in the spotlights around town, some theater lovers turned their attention to an older institution. The Fifth Avenue Theatre, an acoustically balanced, 2,400-seat house with an ornate interior modeled after the Imperial Palace in Peking's Forbidden City, received a $2.6 million face-lift in 1978—fifty-two years after it was first opened. Today, the theater is a home for lavish touring productions.

During this growth period in the late 1970s, galleries sprouted throughout Pioneer Square. Not one or two, but as many as ten good ones. The situation resembled the old story about the small-town lawyer who had no business until the day another attorney hung his shingle across the street. Competition — of the genteel, occa-sionally vicious, artistic type — spurred artists, gallery owners, and buyers. On the one night every month when all the exhibitors unveil their new shows, Pioneer Square is awash with gallery gazers, strolling among sports fans on their way to the Kingdome.

"When I first came here, it struck me that there wasn't a lot going on culturally," recalls an East Coast transplant, who grew up in Manhattan, had an Ivy League educa-tion, and lived in Boston before falling in love with Seattle. "It was a little sleepy. But now you can hardly keep up with it all. It's more sophisticated, in every way."

Opera is an example. Until the early 1970s, if you mentioned opera in Seattle most people thought of the Marx Brothers. But with the good acoustics of the Opera House, the willingness on the part of donors to support it, and the unerring good hand of manager Glynn Ross, something was bound to happen. The breakthrough came with the staging of Wagner's famous *Ring of the Nibelungen* in both English and German. Suddenly, the Seattle Opera Company had itself a summer tourist at-traction, as well as music that was accessible to people not normally drawn to the performing arts.

Seattle dance has also leaped to new heights. When the Joffrey Ballet comes to town, the devoted fan knows that Robert Joffrey danced his first steps in Seattle as a boy. But since he has grown up, so has the town. The city's residential company, the Pacific Northwest Ballet, has struggled through some lean years but it has found a home. Its annual Christmas staging of *The Nutcracker* is a crowd-pleaser and as much a part of the holiday season as the December lights atop the Space Needle. In the mid-1980s, the ballet community welcomed back Mark Morris, who grew up in the Mount Baker district, went

on to fame in New York, then brought his innovative dance style back home to Seattle and set up a small, residential company.

Another native son, the late Mark Tobey, is one reason the Seattle Art Museum has enjoyed its international reputation. Tobey, who loved the city during the middle part of the century, studied the faces and moods, the low clouds and men of despair. Even after moving to Switzerland, Seattle remained part of his art, especially the Pike Place Market. The Art Museum has more than a hundred Tobeys—from early figurative works on the Market to later abstract paintings. Museums from all around the world have offered exhibits of their national treasures for a chance to show some of Seattle's Tobey collection.

The Art Museum is also home to one of the finest collections of Oriental jade in the world. The Asian influence has always been felt in the neighborhoods of Seattle, and the soul-nurturing aspects of Far Eastern culture have been a key to the city's art. At Volunteer Park, Noguchi's double-faced *Black Sun* is a cherished work of outdoor art which seems to express the feelings of Seattle residents toward their source of light and heat.

Outdoor sculptures—in large part the result of a city-financed arts program that has been praised as a national model—have brought warm touches to buildings and parks throughout Seattle. But then, it only seems natural that the lonesome figures in *Waiting for the Interurban* should blend with the canal view in Fremont, or that Henry Moore's black *Vertebrae* should stop pedestrians on Fourth Avenue. They join older, more established figures—the venerable bronze rendering of Chief Sealth in Belltown, the statue of George Washington in the University District—in elevating the urban experience and making Seattle an oasis of art, surrounded by the random sculptings of nature.

THE MAGIC MARKET

What makes a city? Monuments of glass and steel? A tennis court in every neighborhood? A place to work, a place to play, and a place to park? In varying degrees, yes, they all matter. But what really separates a collection of houses and businesses bound together by a string of stoplights from a great city are the numerous diverse, daily surprises. At Seattle's Pike Place Market, a grab bag of global amenities is gathered in one corner of seemingly total chaos.

The Market, ever moving, ever changing, never passive, never bored, is a good nominee as the centerpiece of the city. As Roger Sale wrote in *Seattle, Past to Present:* "For many people the Market is Seattle, its one great achievement, the place they love most, the place they take visitors first." Consumer tastes come and go, but the

Market's appeal has never diminished. Even as shadows of futuristic office towers creep over rickety fish stalls, and salmon-colored condos cling to old hobo haunts, the Market pulses.

Cross First Avenue at Pike Street and there you are: capitalism in its most raw and rowdy form, with a human face. Buy a newspaper from Bangkok at the corner newsstand; turn around and order a slice of spiced pizza from one of the city's oldest Italian delis; move farther down past jo-jos baking behind red lights, where fish vendors assault you with their unbeatable prices and infectious banter. Laugh at the geoducks, or, better yet, send one to your cousin in Bloomington. Poke at the crabs. Eye the octopi. But don't fondle the sea urchins.

Turn the corner, the produce is on display—stalls of bright-scrubbed carrots and exotic roots with apples here, peaches there, and an occasional imported kumquat. Move along. Bonsai growers are waiting patiently, patiently, for the stroller in the mood to buy a midget shrub. Here are shades of jade, jewelry stalls, homespun wool, rainbow kites. More relaxed than the fresh food vendors, these merchants know their handiwork will be just as valuable tomorrow. So sit and chat.

Look out toward the water. The Olympics may shape a silhouette against a moody sky. Cross the cobblestoned street. A scent of old Morocco drifts by. Sip a cup of *café au lait,* before or after the Vietnamese catfish soup. Nearby, musical ambience takes the form of an Elvis Presley impersonator crooning an a cappella version of "You Ain't Nothing But a Hound Dog." Throw him a few quarters, but save some change for the string quartet playing a melody a few international flavors away from the blind folk guitarist.

All of this has been going on, in one form or another, since 1907, when a small group of truck farmers opened a few produce stands in an attempt to cut out the middleman. Many were Japanese—Issei settlers who farmed the Duwamish Valley and provided, at one time, up to 75 percent of the produce for the city.

Artist Mark Tobey found his inspiration in the ebb and flow of the Market. During the Depression, for days on end he came and studied the faces and listened to the rhythms of its commerce, the hectoring voices of the crab merchants and the halibut hawkers. "It needs no help," said Tobey of the Market. "It passes fast enough. People not pressed for time will find their own patterns of intricate beauty."

The Market did need help once, in 1971, when it took a citizens' initiative to ensure preservation. The leader of the campaign was Victor Steinbrueck. When he died in 1985, they named the little park with the totem pole just north of the Market after him. Now a well-used spot, it is a museum of human diversity, like the Market itself.

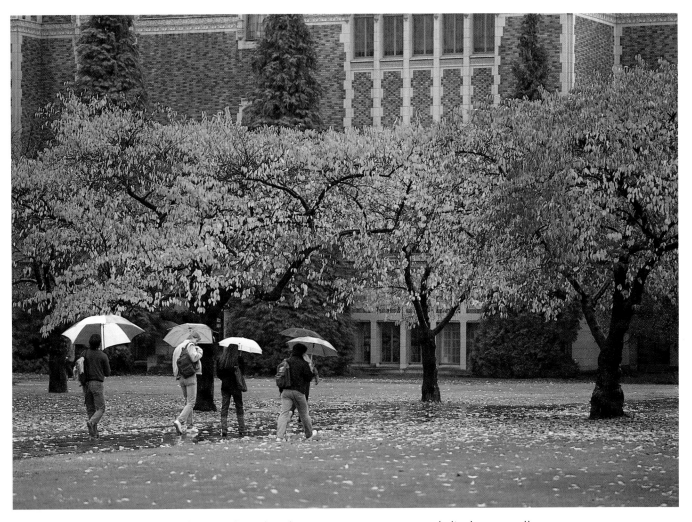

■ *Above:* When the cherry trees are on seasonal display, a stroll through the University of Washington's Quad can be a sensory treat for harried students of the "U-District." ■ *Overleaf:* Magnolia Bluff is ten minutes from downtown and only a glance from Puget Sound.

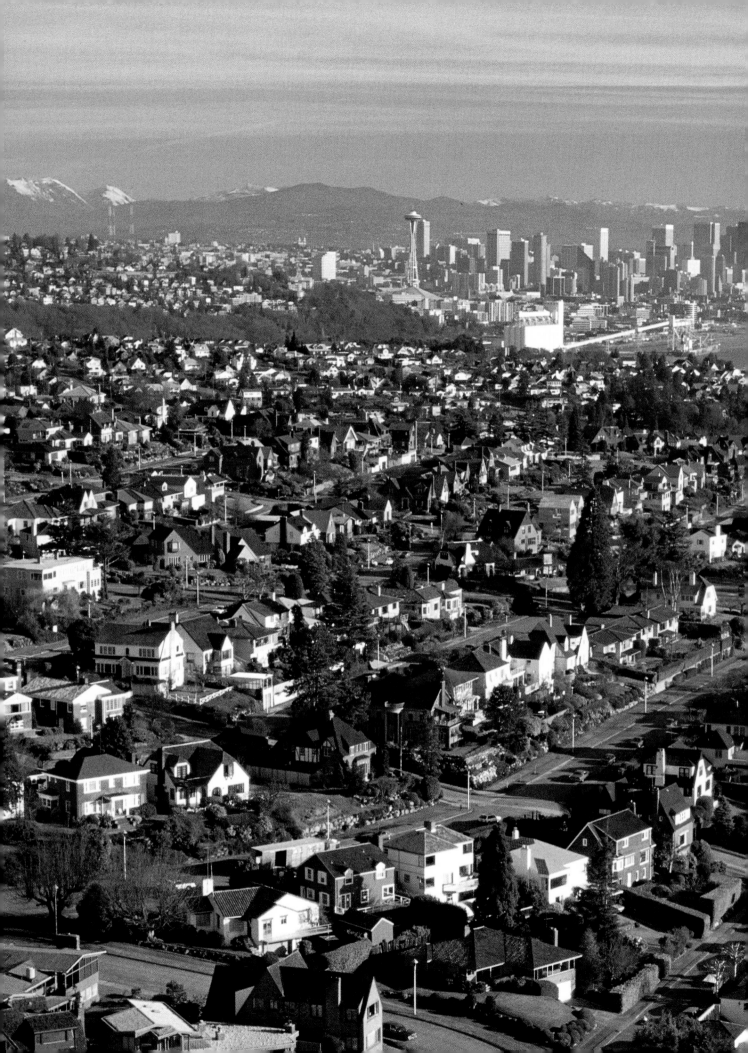

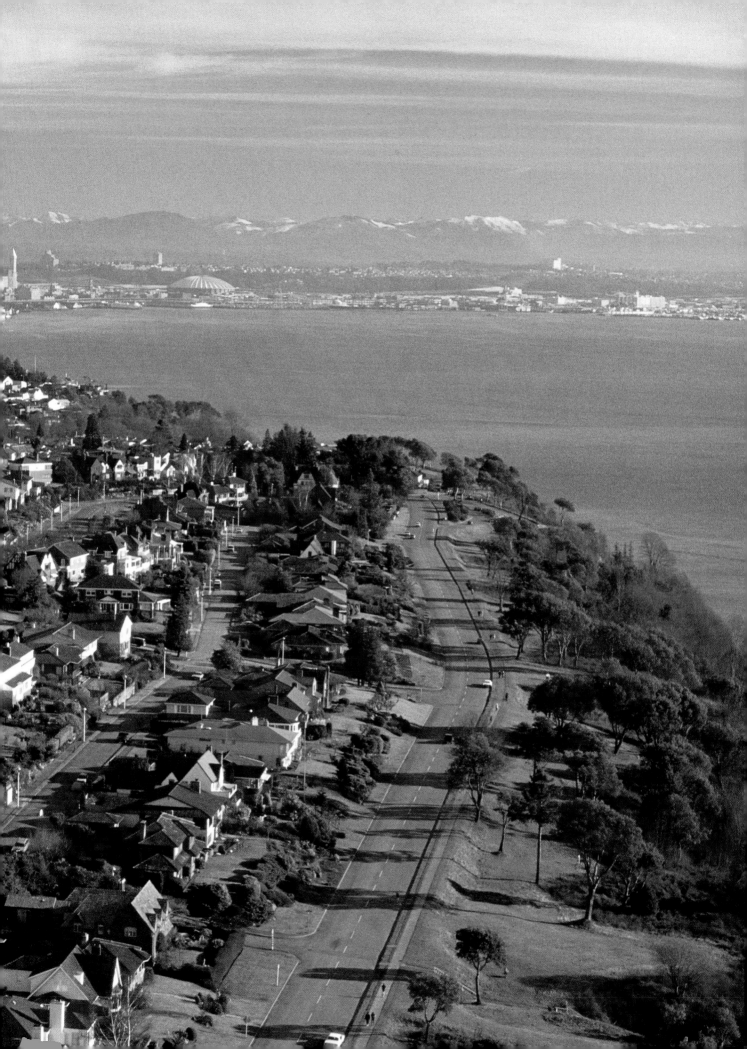

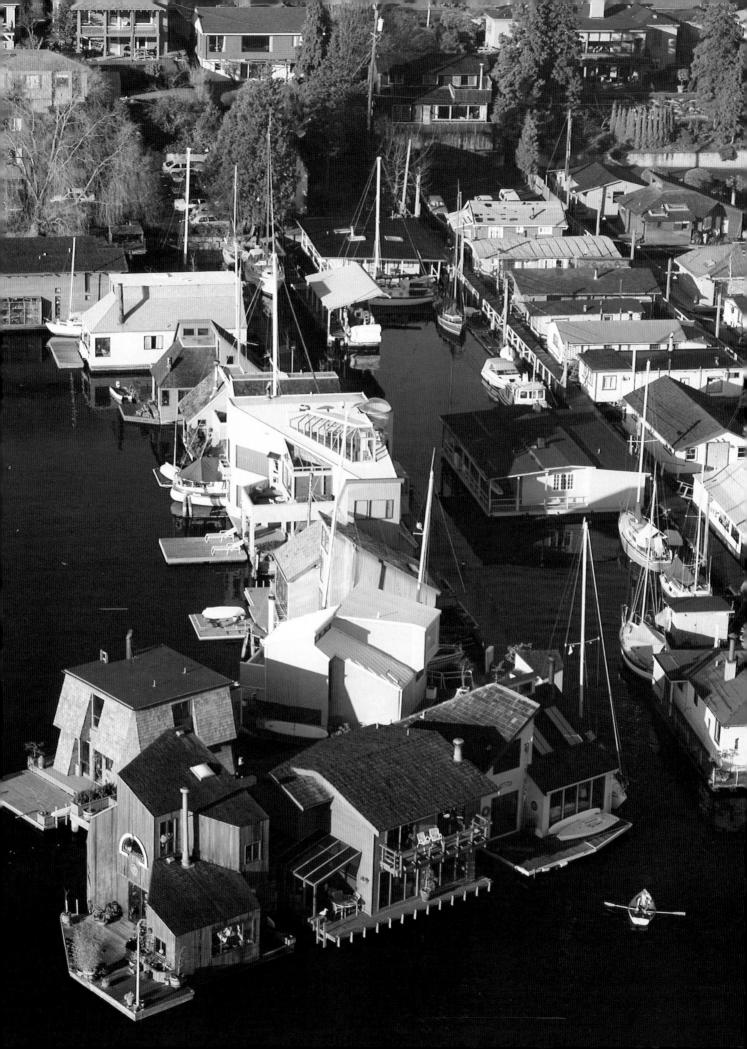

■ *Left:* Lake Union houseboats make use of every inch of available space. ■ *Above:* Clinging to a hill over Lake Washington, the Mount Baker District was developed by David Denny, who was the younger brother of the more famous Arthur Denny.

More than seventy years ago, Green Lake became part of the Olmsted brothers' master park plan. The park system has grown from a donation by pioneer David Denny to five thousand public acres.

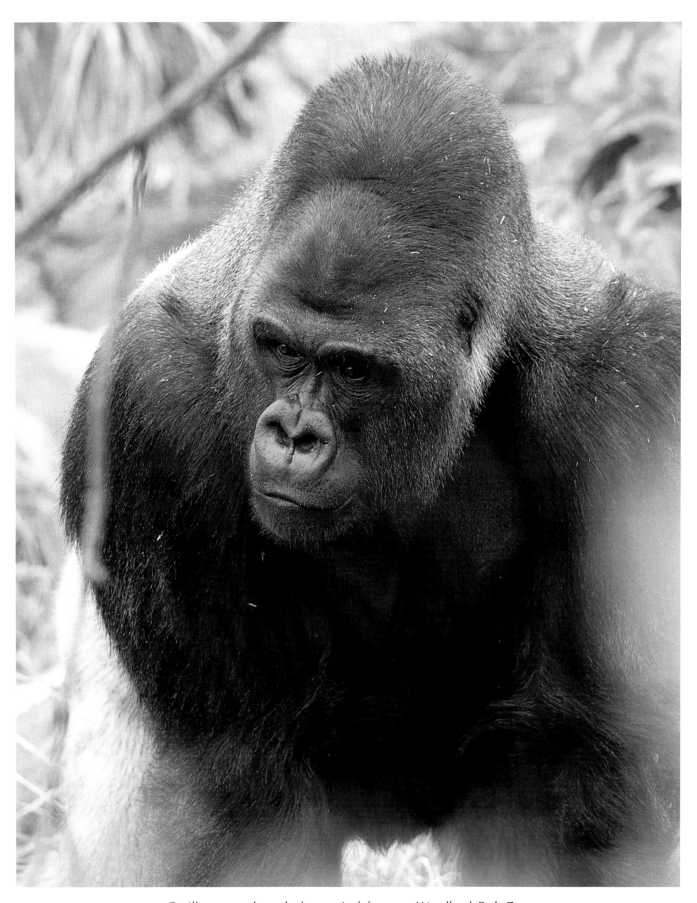

Gorillas romp through the tropical forest at Woodland Park Zoo, which has become famous for the natural settings created for the over one thousand animals, birds, and reptiles it houses.

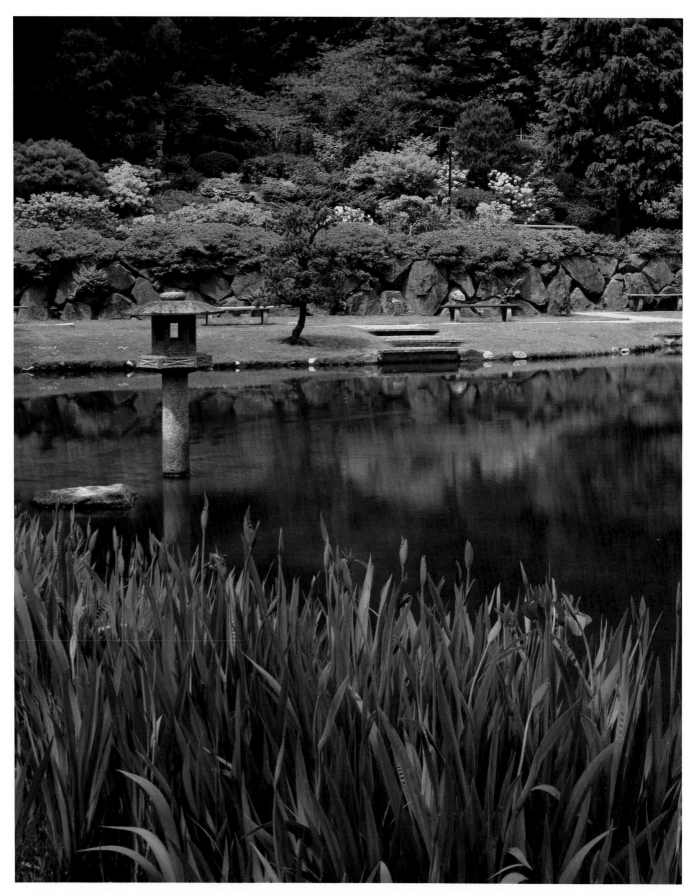

■ *Above:* The Arboretum's Japanese Garden requires not only pruning but also patience; the reward is a delicate landscape of outdoor artistry. ■ *Right:* Landbound no more, a visitor without fins has a glimpse of life under the Sound in the Aquarium's Underwater Dome.

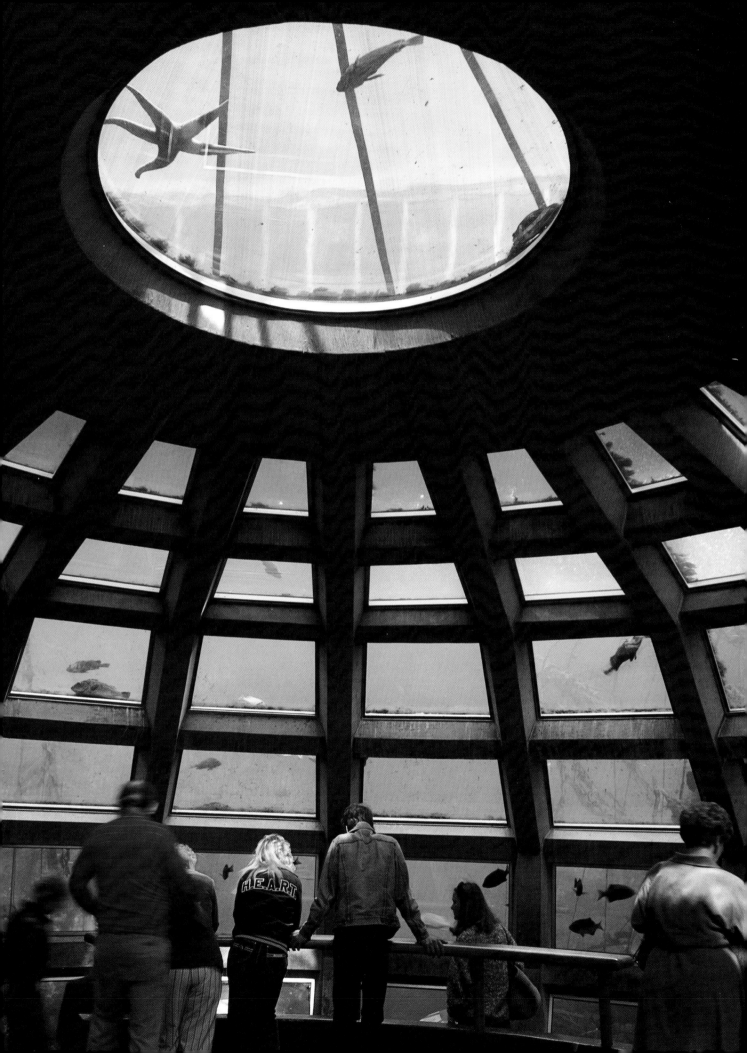

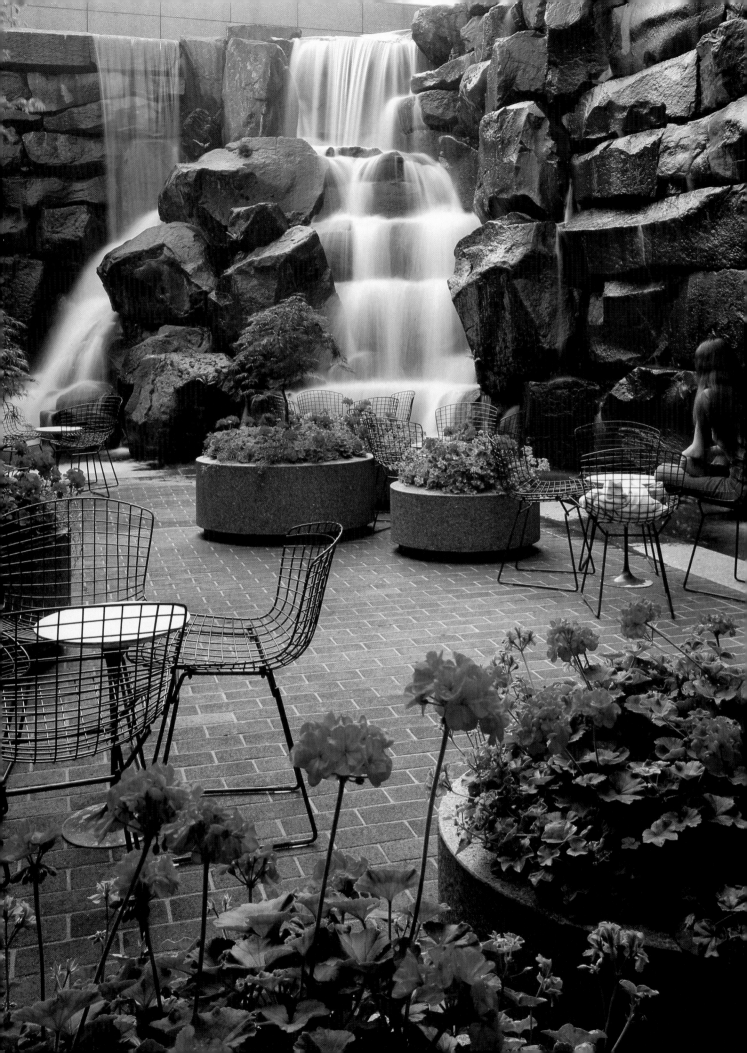

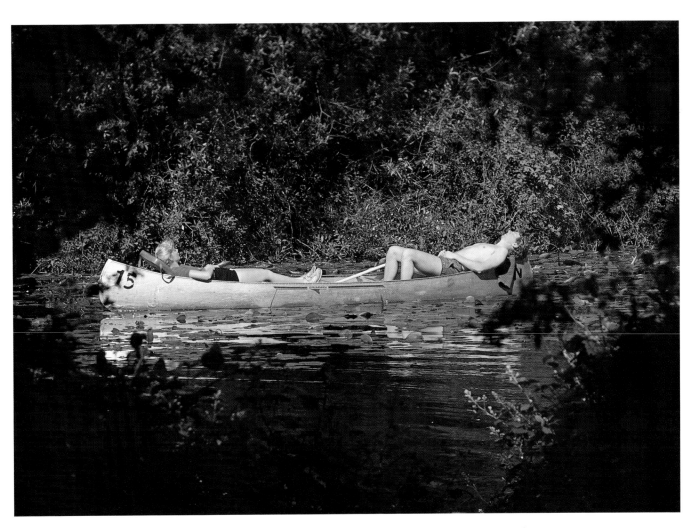

■ *Left:* Amid the bustle of Pioneer Square, tiny Waterfall Garden Park offers a soothing retreat. ■ *Above:* Another urban delight, canoeing on Lake Washington is most popular in the early spring.

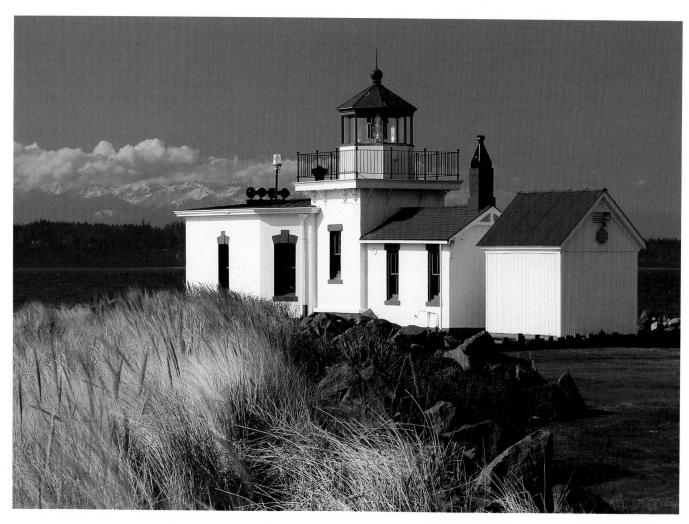

Those who take the winding trek through Discovery Park's wilderness are rewarded with this vista of the West Point Lighthouse, built in 1881 to guide ships approaching the entrance to Lake Washington Ship Canal to the north and Elliott Bay to the south.

■ *Above:* One of the best places in Seattle to set a kite aloft is atop the man-made mound in Gas Works Park. This unusual park on the shore of Lake Union incorporates the skeletal remains of an industrial plant.
■ *Overleaf:* The Volunteer Park Conservatory crowns Capitol Hill.

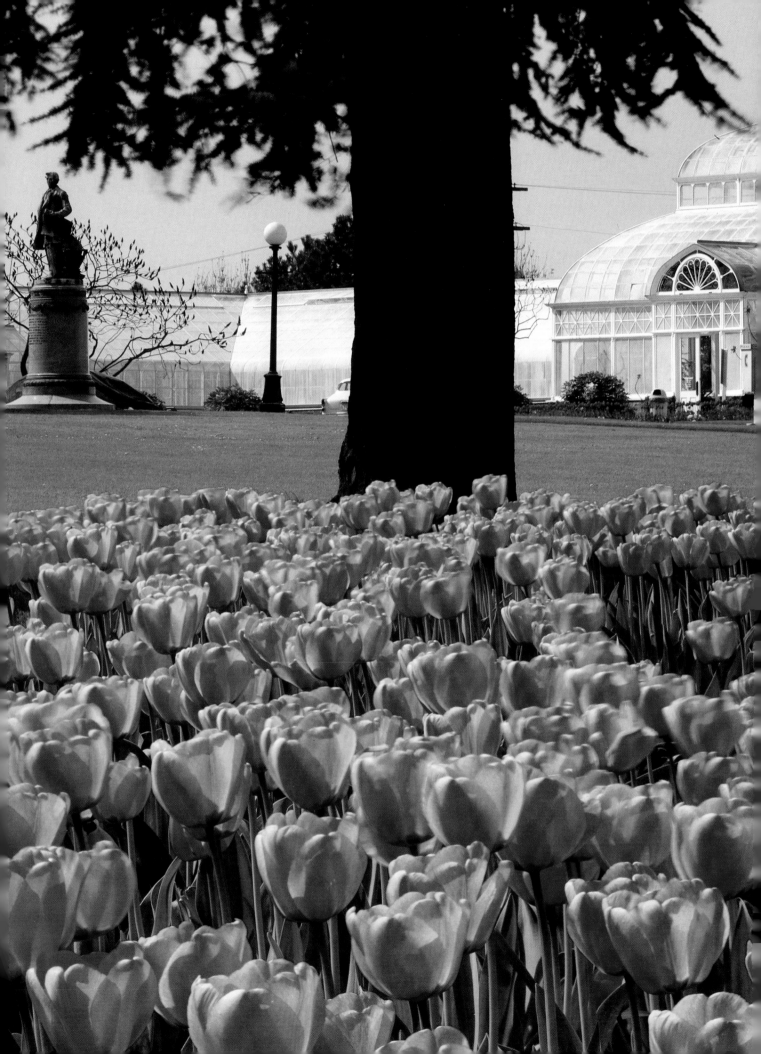

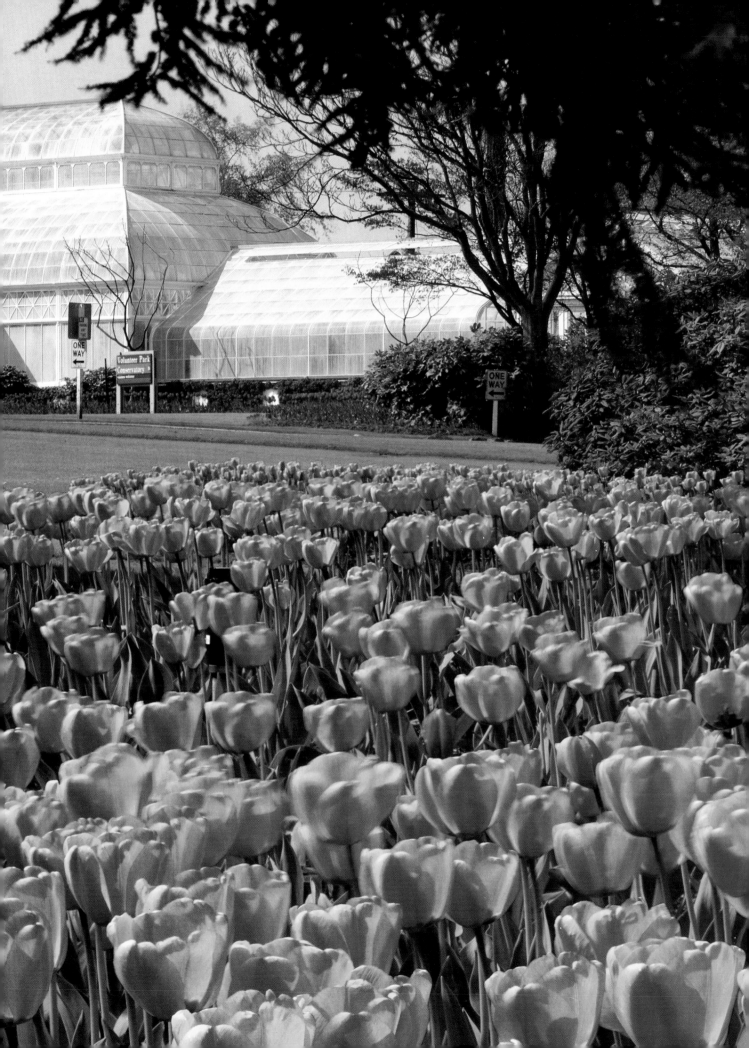

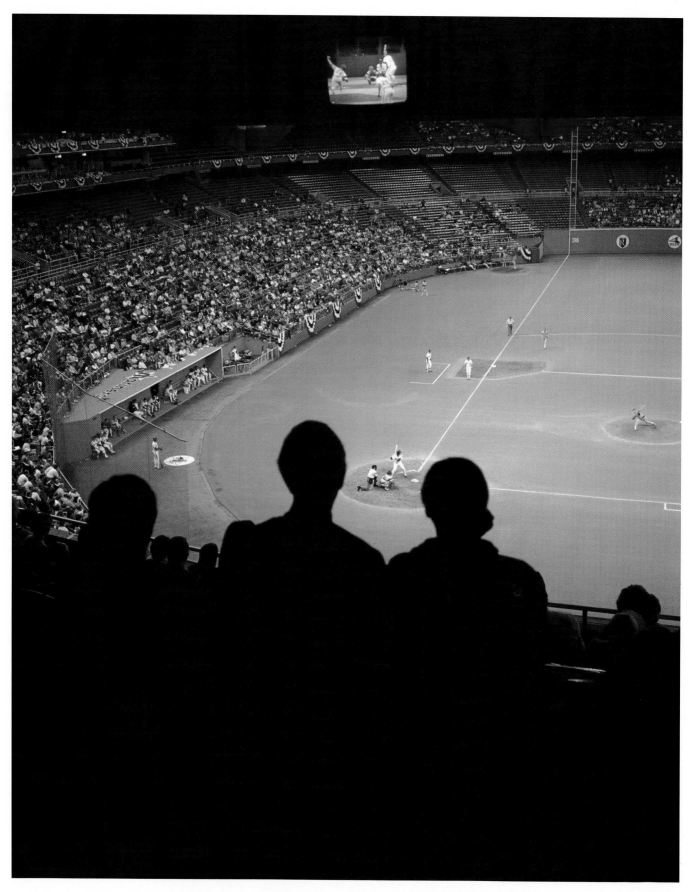

Major league baseball became popular in Seattle when the Mariners
opened their first season inside the Kingdome in 1977. A Mariner fan
can get peanuts, popcorn, and an instant replay on the television set
overhead—all the creature comforts of indoor ball.

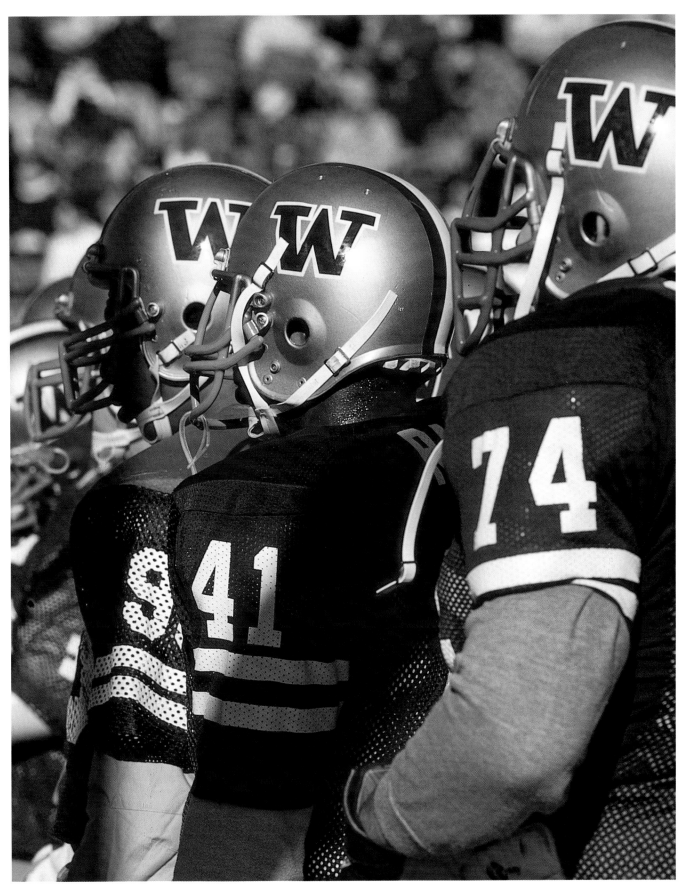

Towers of tenacity, the purple and gold uniforms of the University of Washington are the colors of a national football powerhouse. The Huskies play in the Pac Ten Conference against such rivals as USC, Stanford, Washington State, and the University of Oregon.

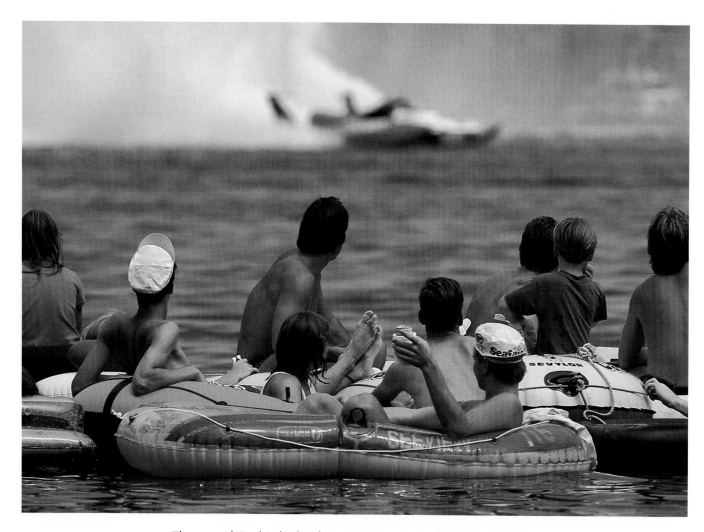

The annual Seafair hydroplane race is supposed to be a spectator sport, but fans tend to become part of the act as the mercury climbs. Ever since a speedboat named the *Slo-mo-shun* hit 160 miles per hour in 1950, this race continues to draw up to half-a-million people.

Fans come from as far away as Portland, Oregon, and Anchorage, Alaska, to scream for the National Football League's Seahawks. Seattle showed instant love for the team with advanced ticket sales of fifty-seven thousand seats before their first kick-off in September 1976.

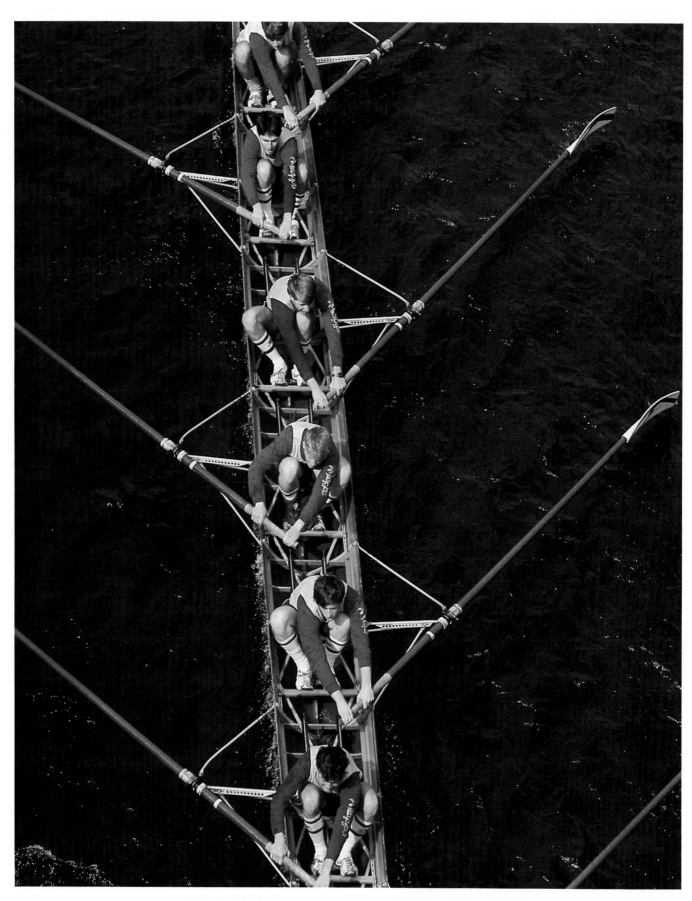

A Seattle Pacific University crew slices through the water at the
Montlake Cut. On opening day, the first Saturday in May when the
yachting season officially begins, everything from kayaks to oceanic
cruisers cram this waterway in celebration of the nautical life.

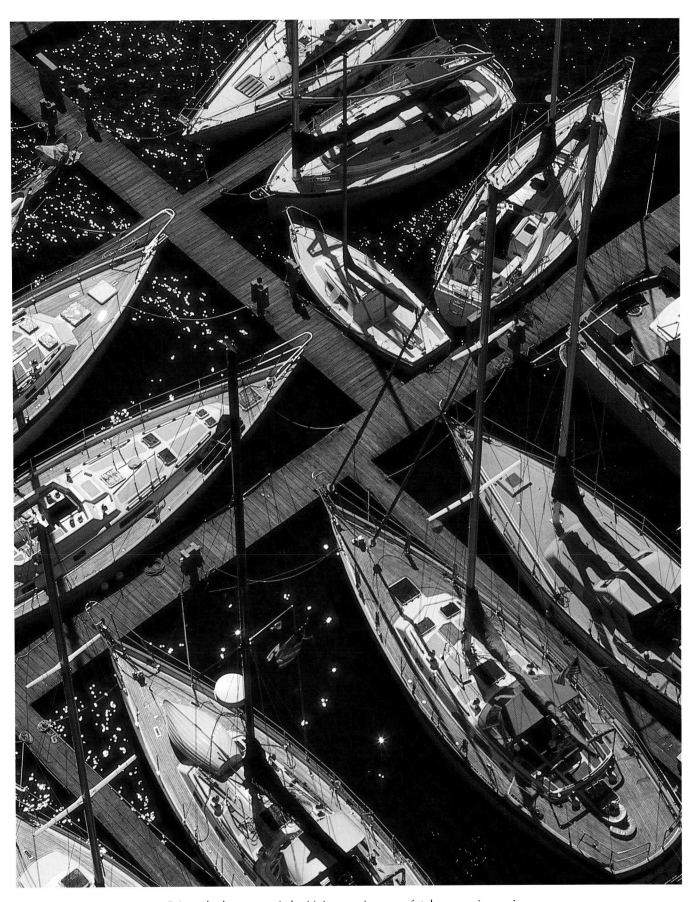

Prime dock space at Lake Union marinas can fetch a premium price.
But few weekend and after-hours sailors ever complain about the
location—just minutes away from their desks in the city's center.

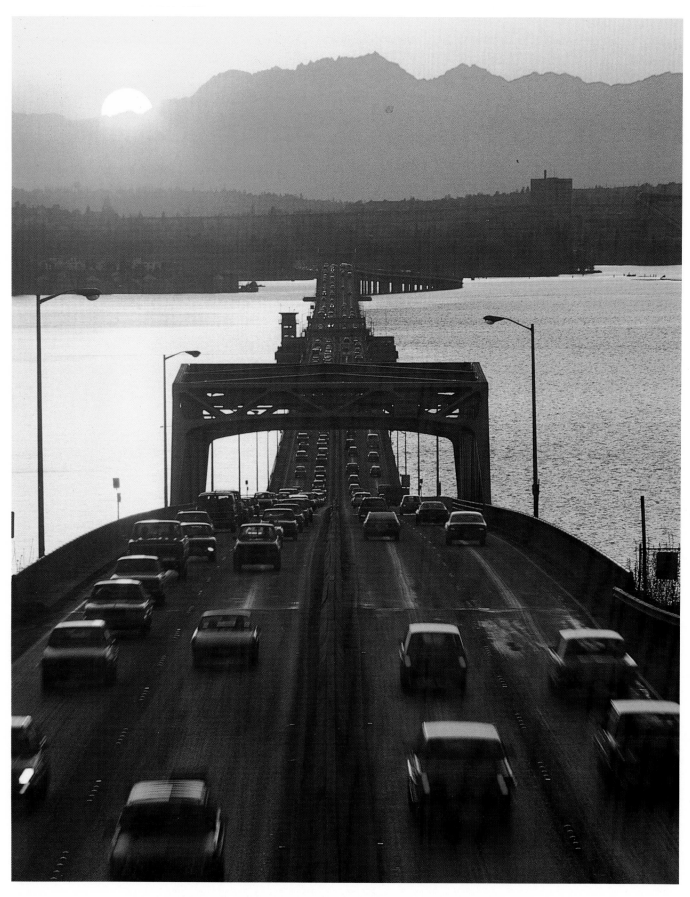

■ *Above:* The Evergreen Point Floating Bridge, connecting Bellevue to Seattle, is the longest floating span in the world. ■ *Right:* Design styles change, but beauty stays in fashion. The pyramidal tops of the King Street Station and the cherished Smith Tower rise against the beige First Interstate Center and the boxy Seafirst Bank Building.

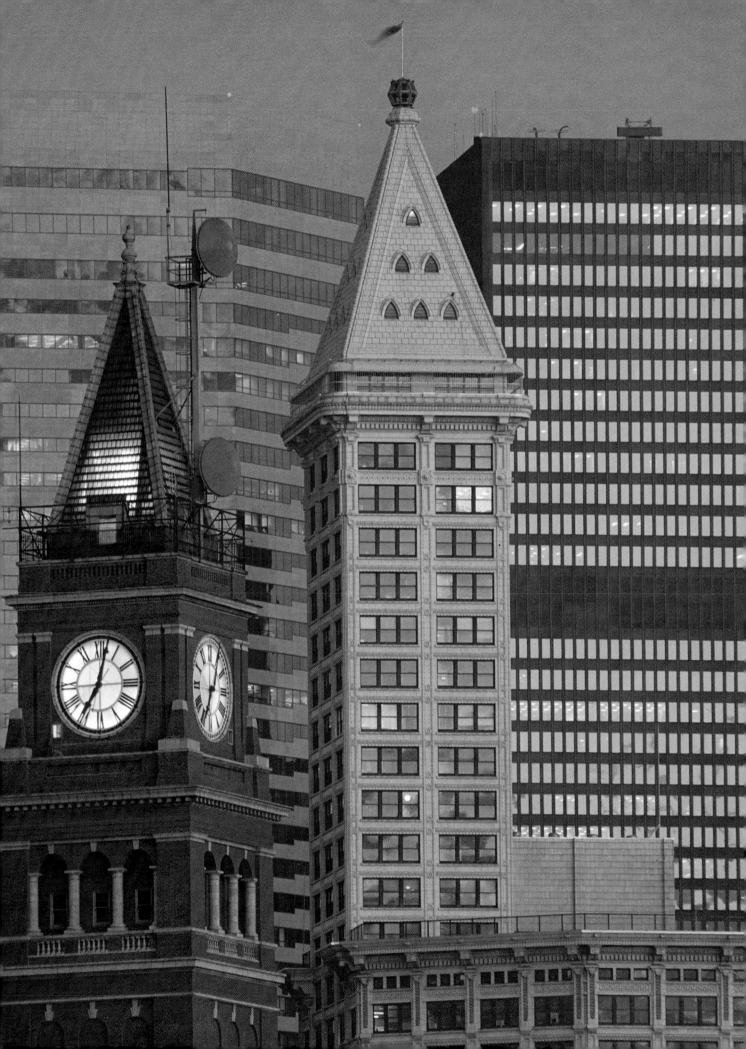

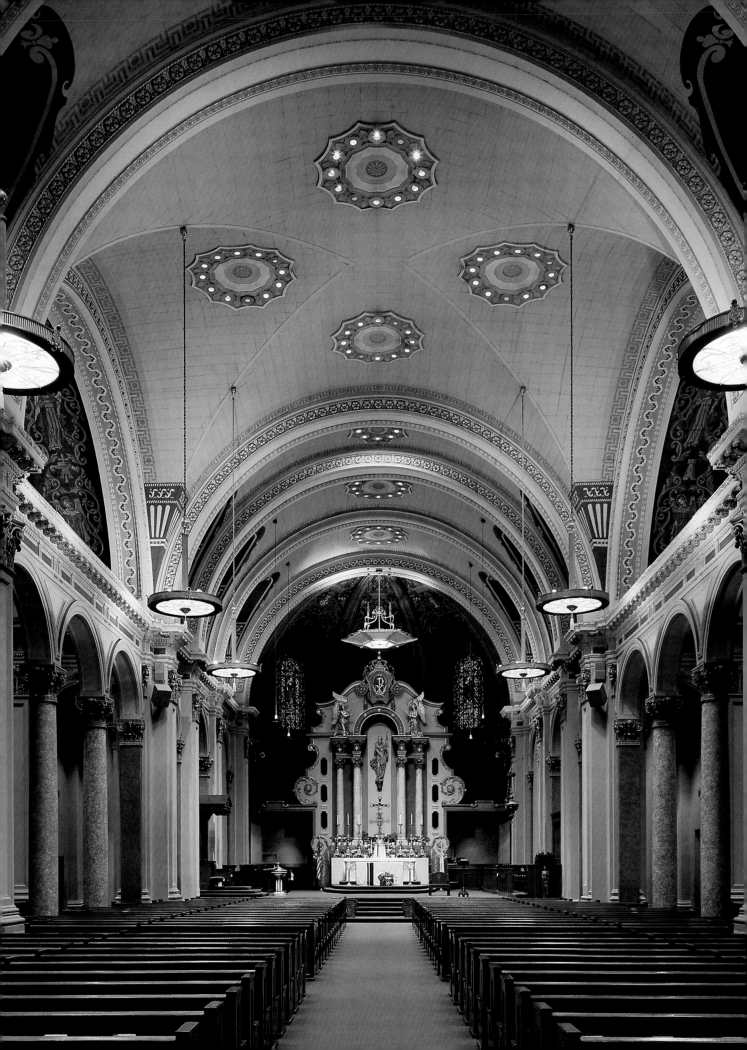

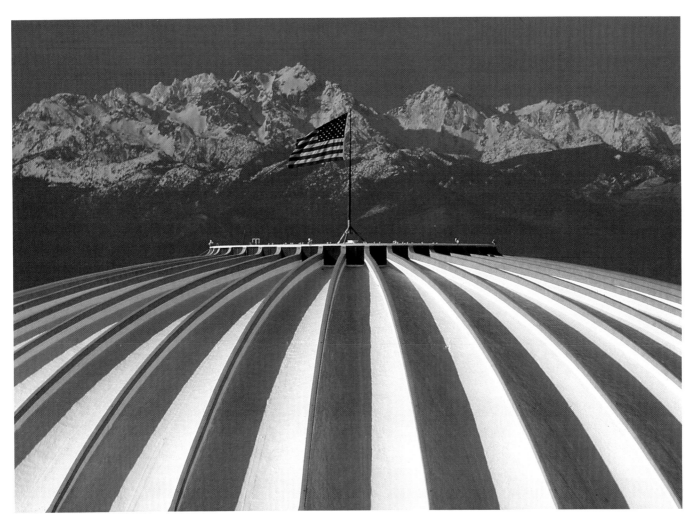

■ *Left:* The Renaissance-styled Saint James Cathedral is the mother church of Seattle's Catholic Diocese. ■ *Above:* A dull gray at first, white paint brought out the clean structural lines of the Kingdome's roof. ■ *Overleaf:* A Carl Gould masterpiece, Suzzallo Library rises in the heart of the University of Washington campus.

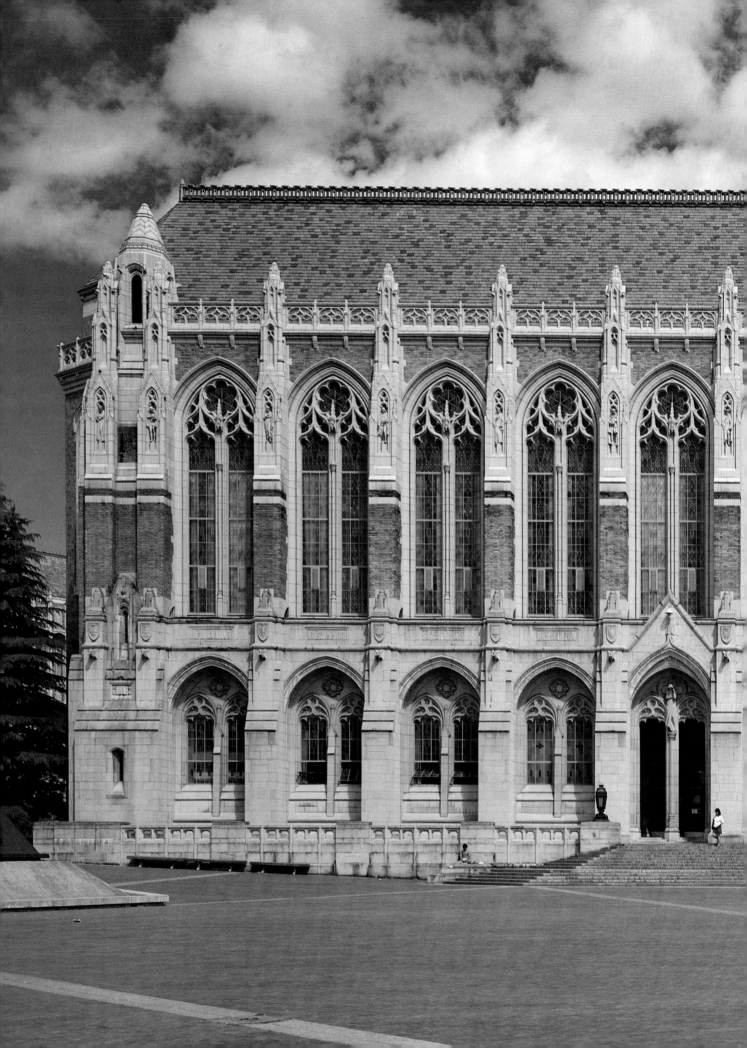

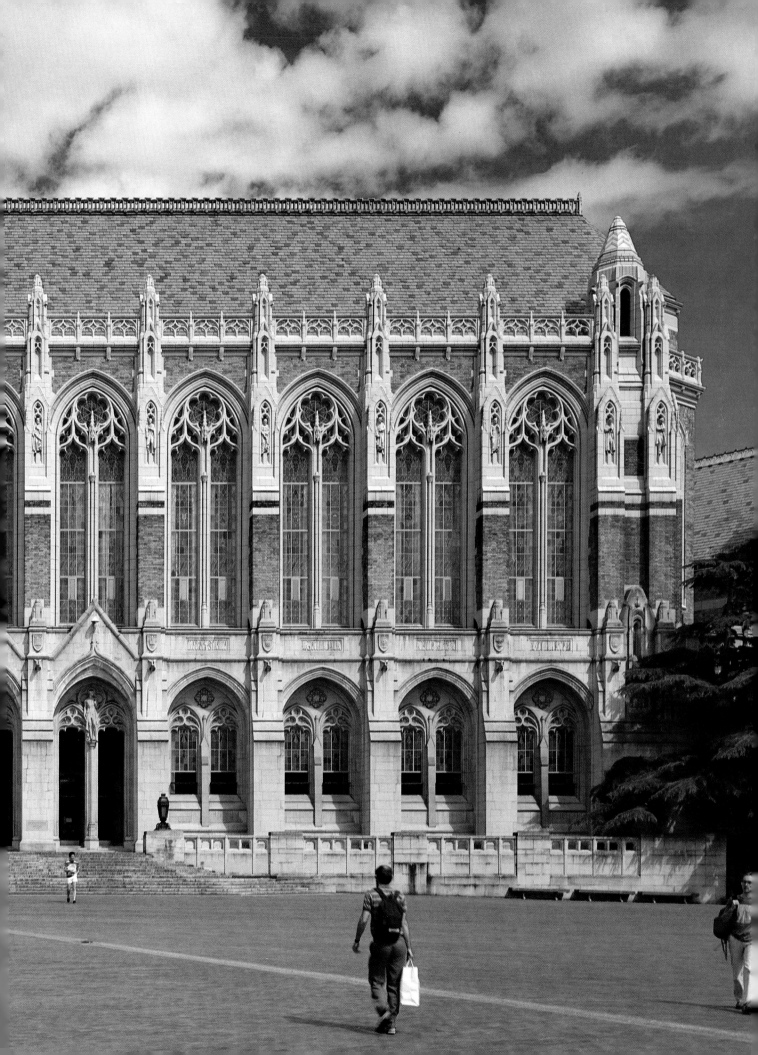

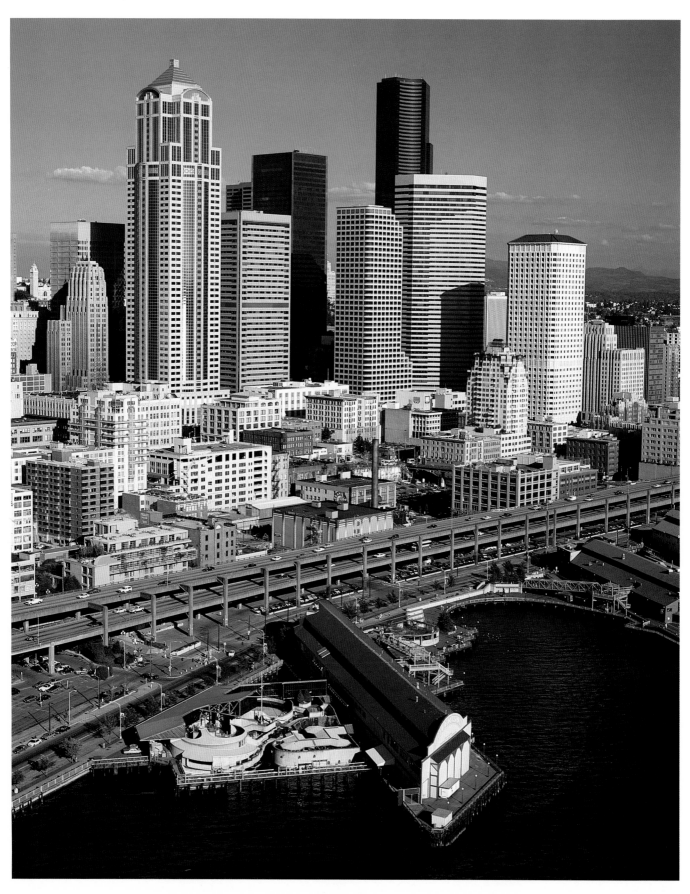

Between Elliott Bay and the new skyscrapers, parts of Old Seattle have been paved over, rebuilt, and restored. Over the past century, Seattle's commercial core has withstood the Great Fire of 1889, two structure-rattling earthquakes, and major regrade projects.

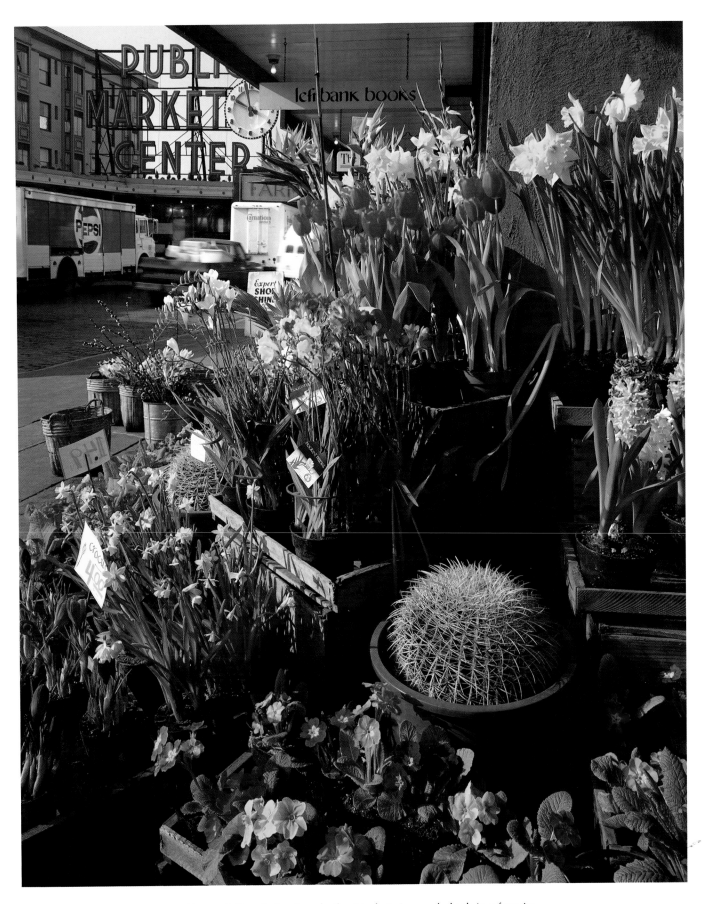

■ *Above:* A Seattle landmark, the Market sign and clock is a favorite terminus when the New Year's Eve countdown begins. ■ *Overleaf:* Dungeness crabs, plucked from the icy waters of nearby Puget Sound, beckon buyers with claws of tender meat.

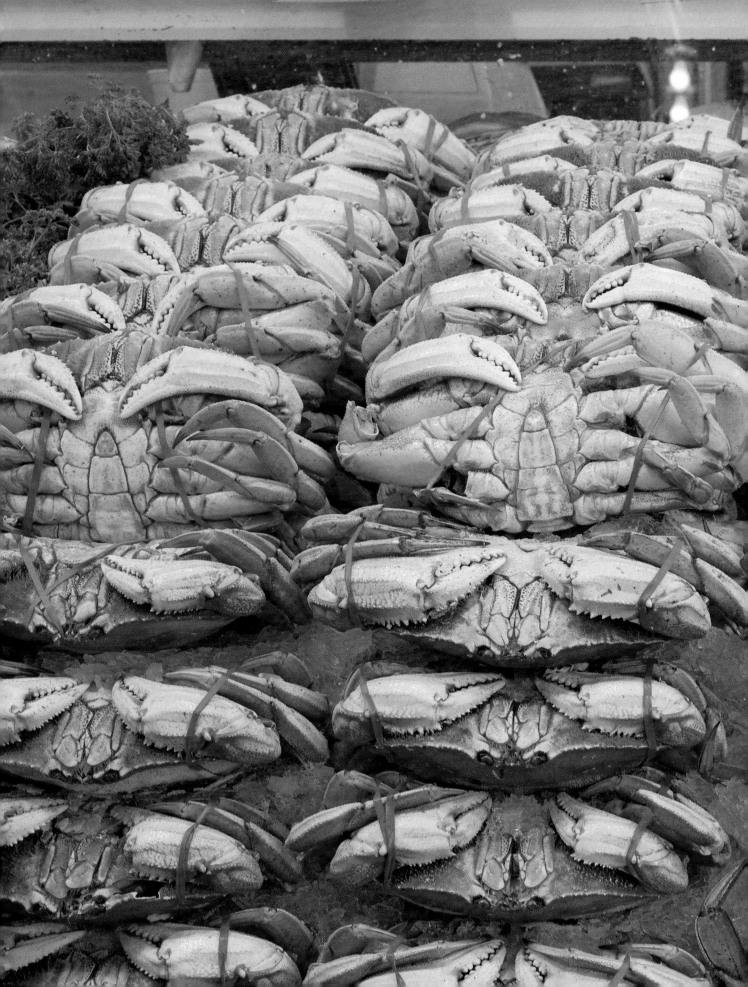

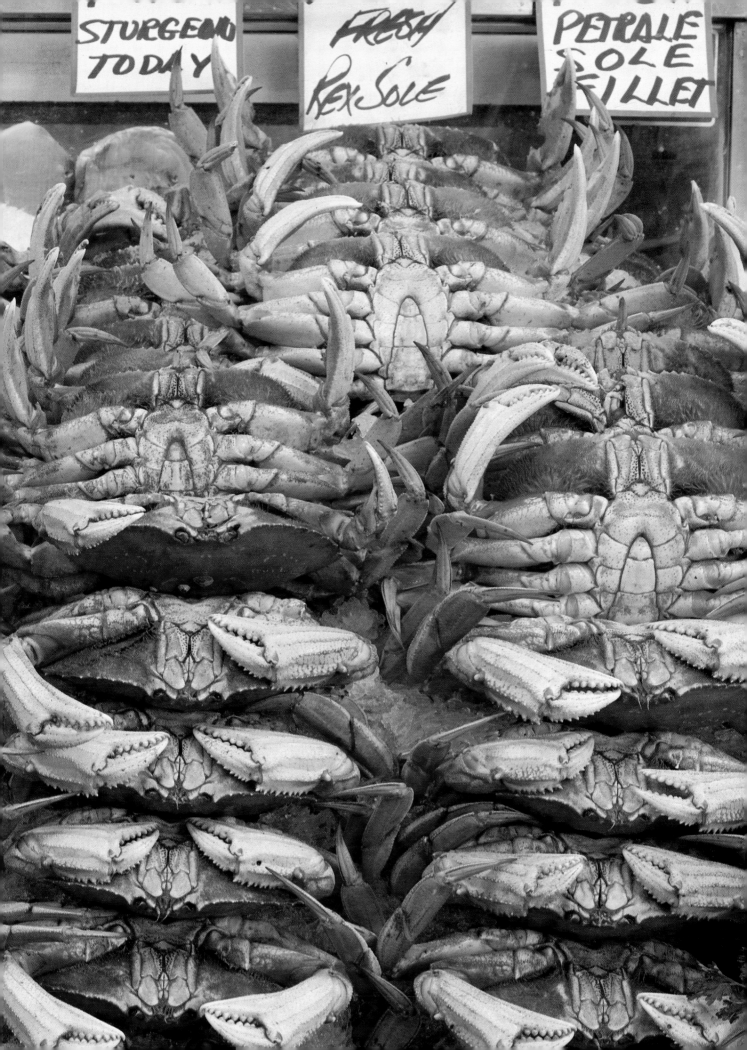

STURGEON TODAY

FRESH REX SOLE

PETRALE SOLE FILLET

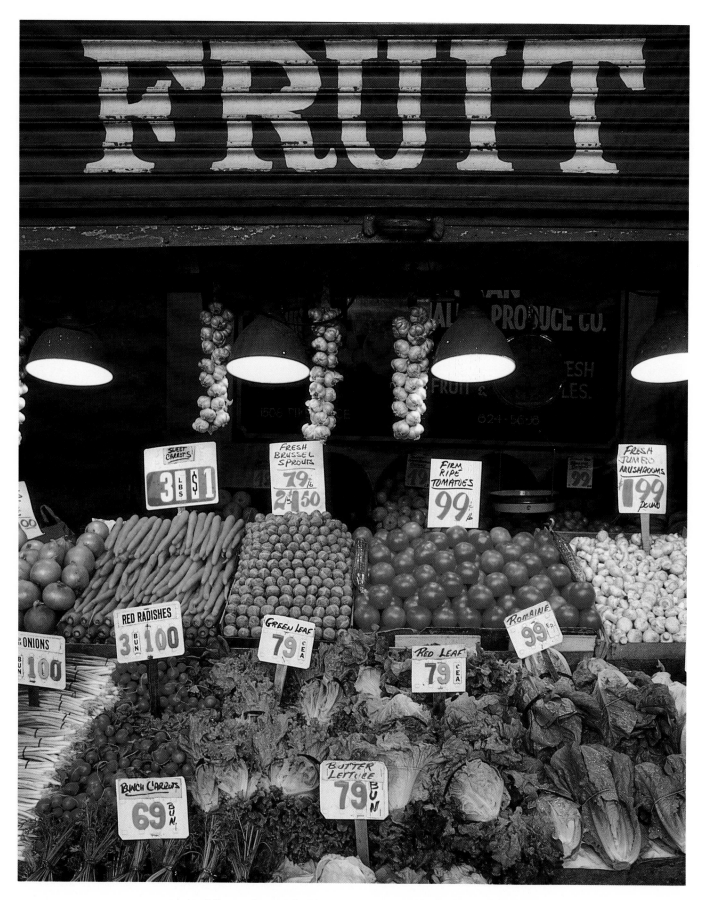

No middleman here. Pike Place Market vendors offer fresh seafoods, vegetables, fruits, rare spices, and a variety of imported delicacies, along with an intriguing mix of accents that give the Market all the air and excitement of an international bazaar.

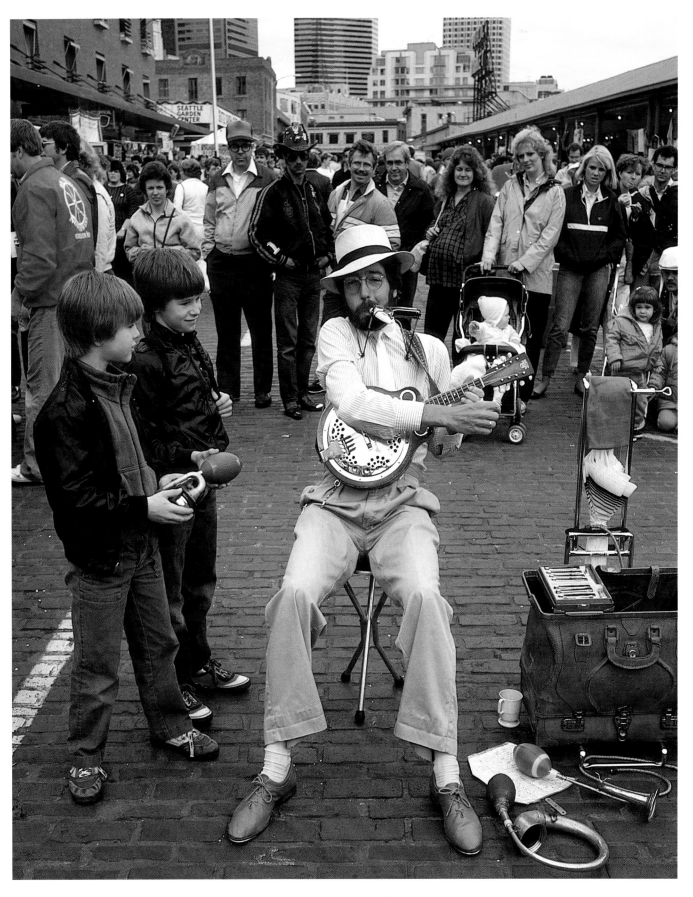

The annual Market Street Fair is much like the Pike Place Market itself: unpredictable, fast-moving, widely entertaining, and a terrific bargain. For many, Pike Place is the city's heart and soul.

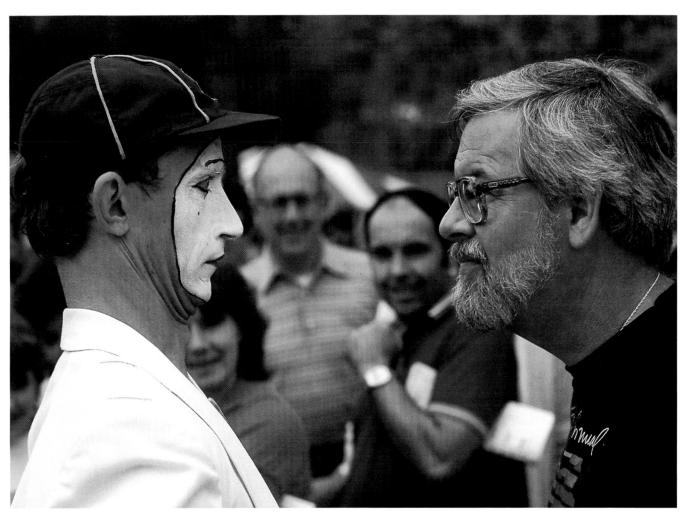

■ *Left:* A ride in the Fun Forest adds thrills to any visit to the Seattle Center. ■ *Above:* Face-to-face with a mime is one way to get involved in the popular Folklife Festival on the Center's grounds.

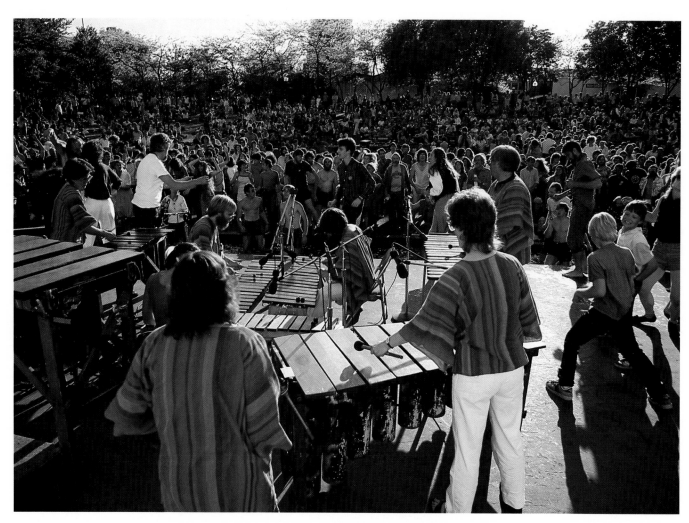

■ *Above:* Visitors to the Seattle Center will use any excuse to dance, and this marimba band makes it easy to move and sway. ■ *Right:* The Pacific Science Center is both a permanent and extremely popular legacy of the highly successful 1962 World's Fair.

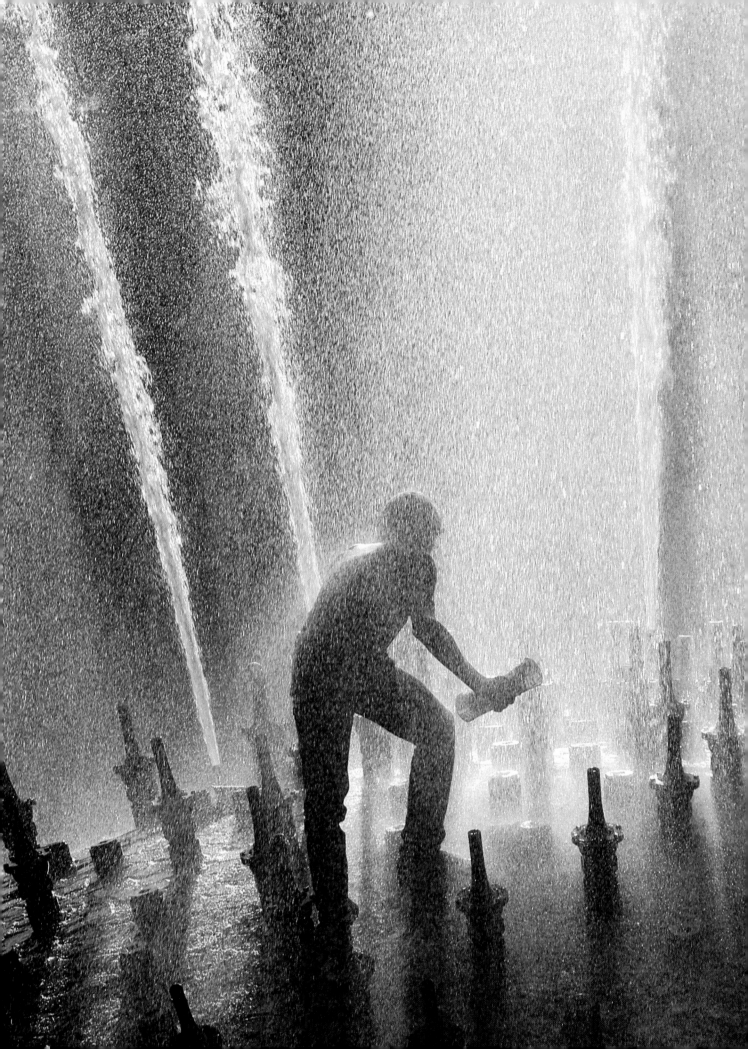

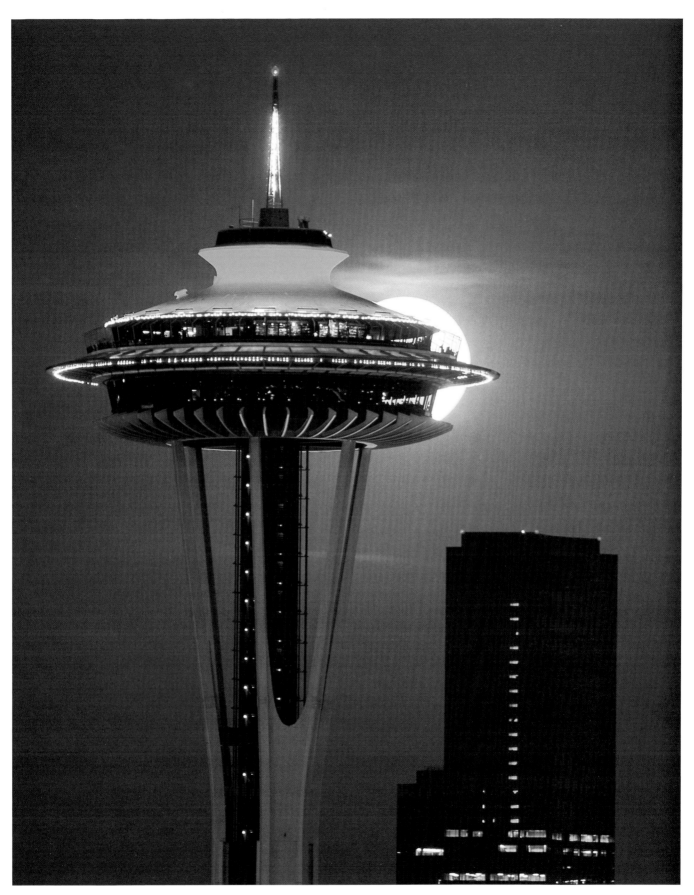

■ *Left:* A child plays a game by placing a cup on one of the 217 nozzles on Seattle Center's International Fountain. ■ *Above:* Some people believe the Space Needle will always look futuristic.

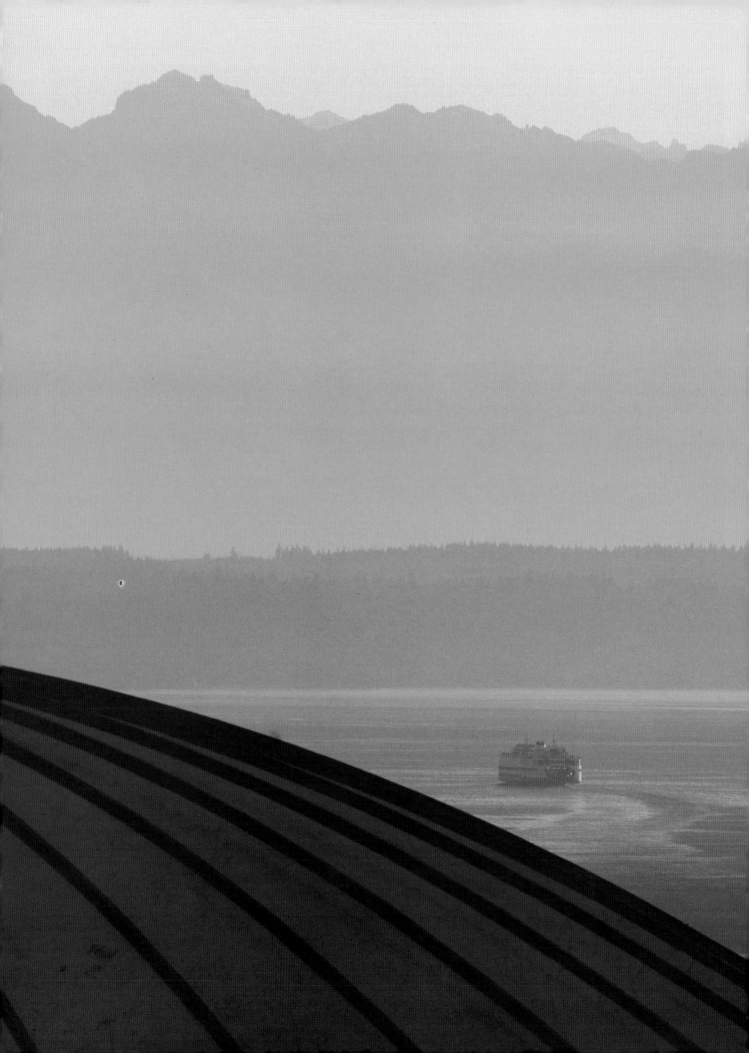

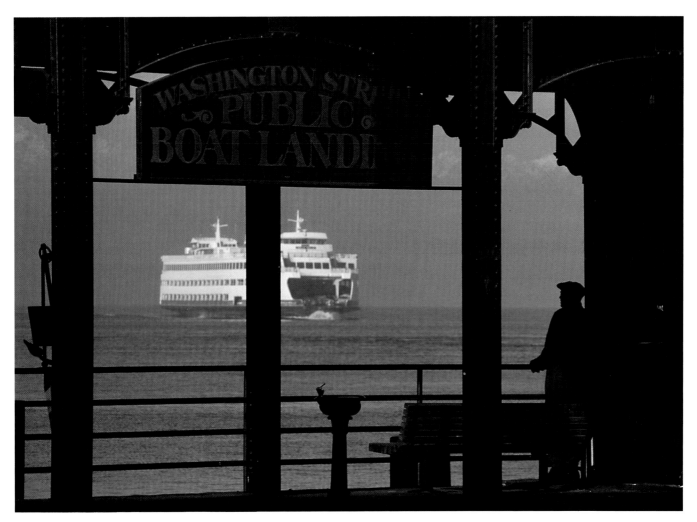

■ *Left:* Part of the nation's largest ferry fleet, a boat heads homeward between silhouettes of the Olympics and the Kingdome. ■ *Above:* Up to twenty million passengers use Washington's ferry system every year. ■ *Overleaf:* Whether it provides food for the lone fisherman or working dock space for Harbor Island, Elliott Bay is vital to Seattle.

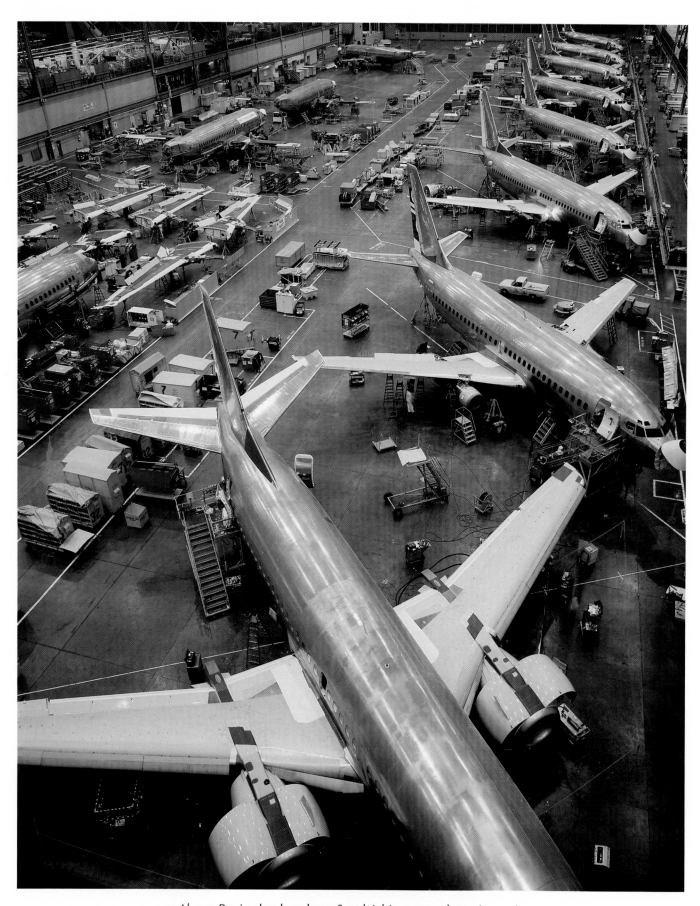

■ *Above:* Boeing has long been Seattle's biggest employer. In varying stages of production, new 737s move through Boeing's Renton plant.
■ *Right:* The Space Needle, Seattle's most famous landmark, is framed by the *Olympic Iliad*. ■ Built over Interstate 5, the Washington State Convention Center is in a parklike setting.

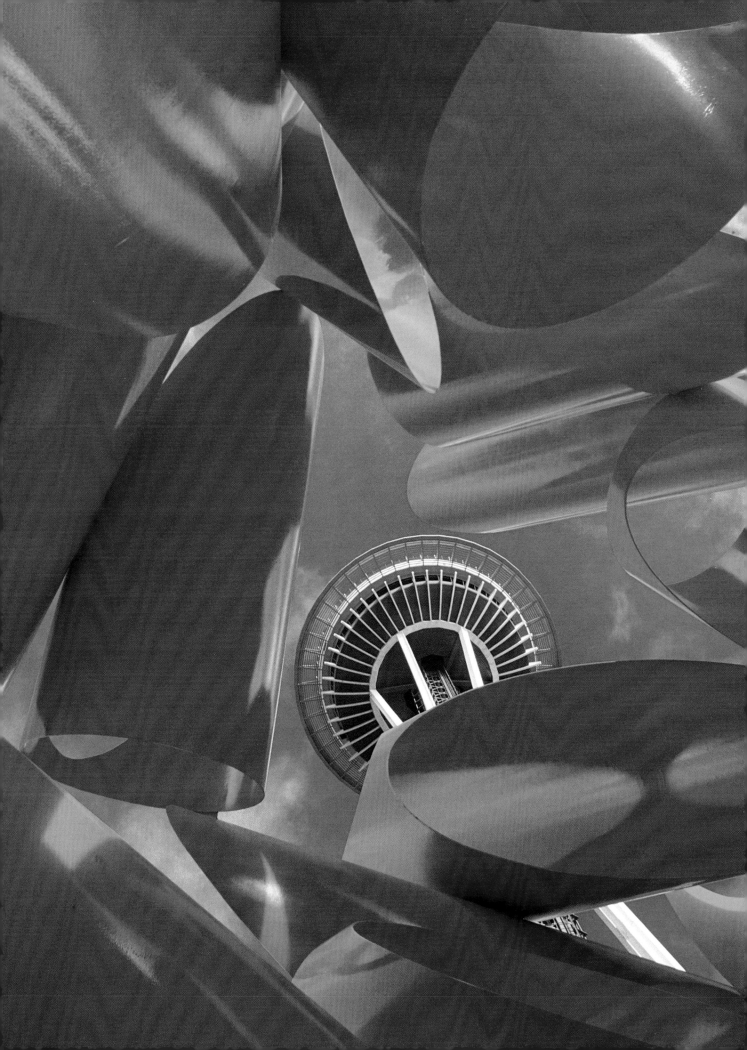

Noguchi's stirring *Black Sun* in Volunteer Park is also practical – when used as a backrest and a porthole through which to view the many constantly changing panoramas of the city below.

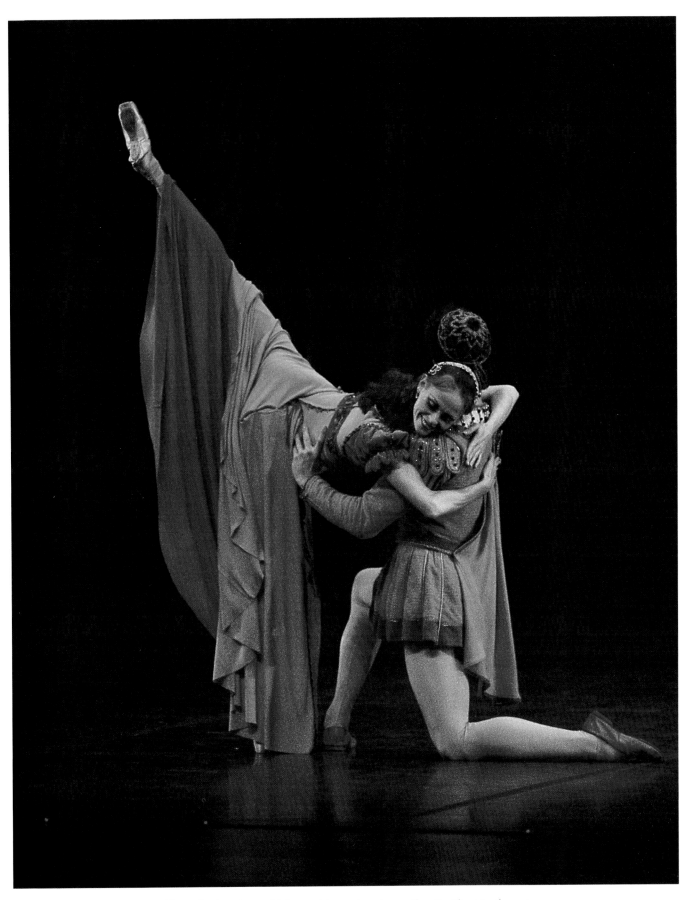

Though skeptics said it could not be done, the Pacific Northwest Ballet Company has a healthy following and ambitious future plans. In addition, Seattle boasts the Seattle Symphony and the Seattle Opera Company as well as five major professional theaters.

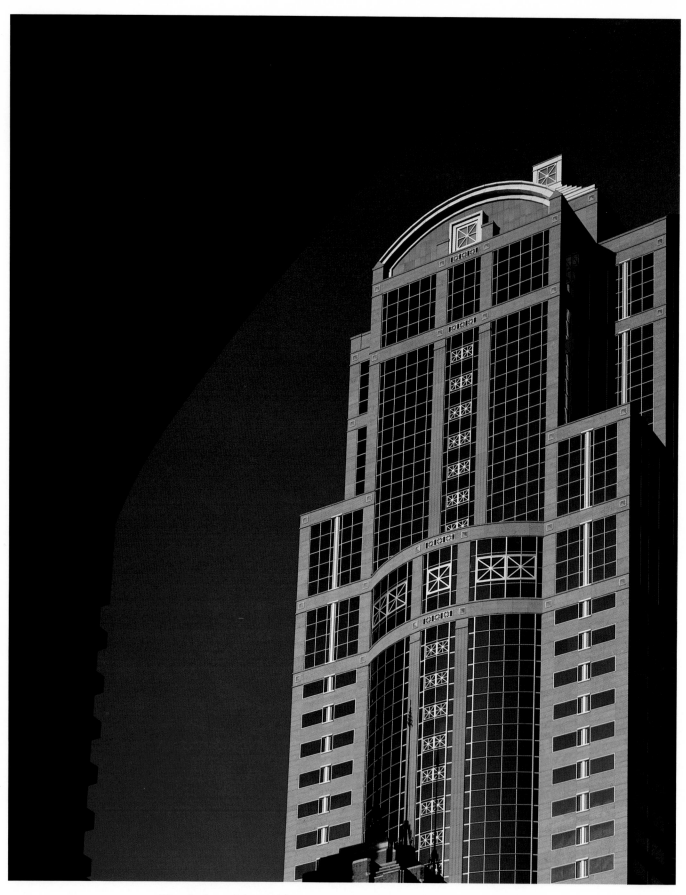

The design of the Washington Mutual Tower, completed in 1988, complements the architecture of the surrounding buildings, some of which were built as much as half a century earlier.

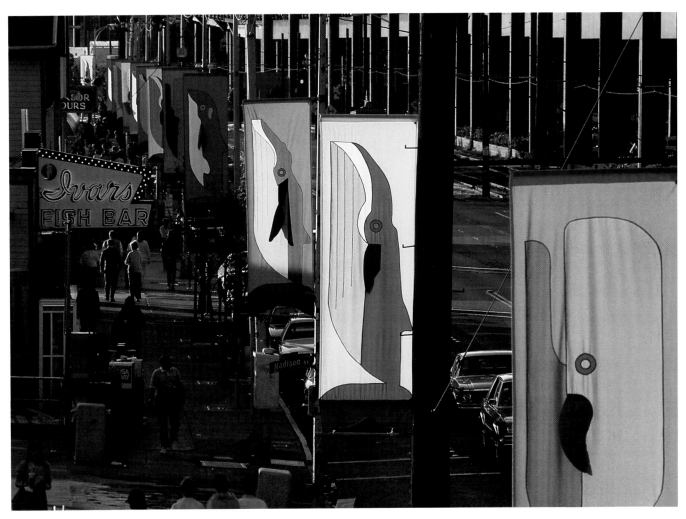

Summer banners along Alaskan Way herald the bustling waterfront
tourist trade. Restaurants, antique and curio shops, and Waterfront
Park are favorite destinations for strollers enjoying the salt-sea air.

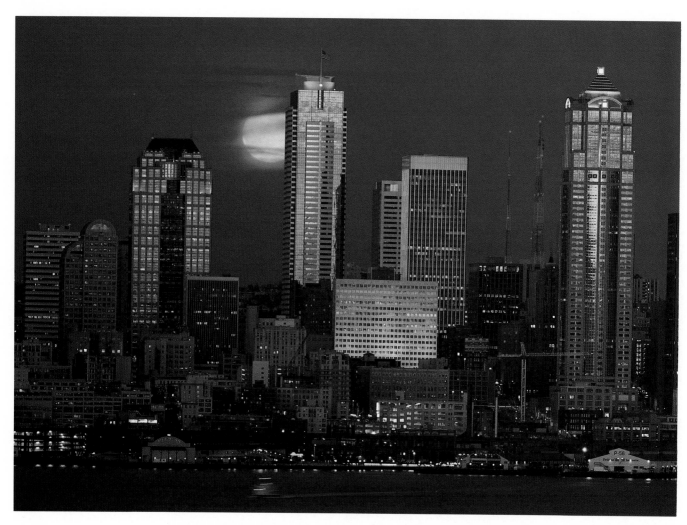

■ *Above:* While Seattle's pace changes at night, the city is alive with concerts, theater, and other cultural events. ■ *Right:* The city is named for Chief Sealth of the Suquamish, a generous leader who greeted the first settlers at Alki Beach in 1851. ■ *Following Page:* Afternoon light bathes the foremost city of the Pacific Northwest with a golden glow.

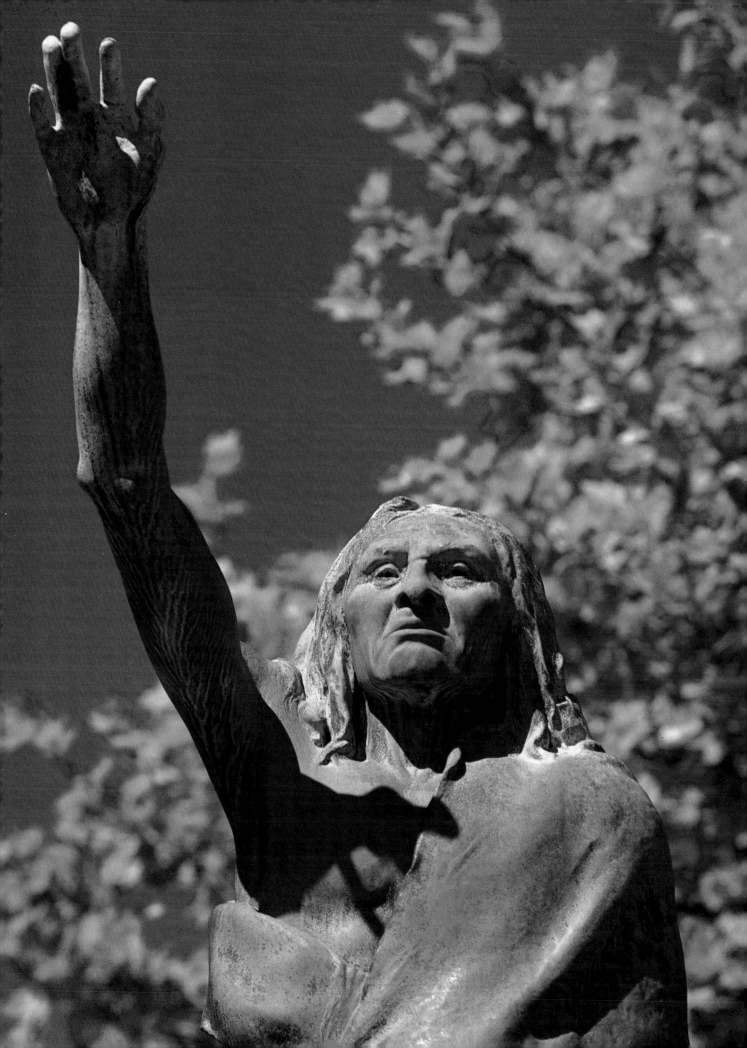

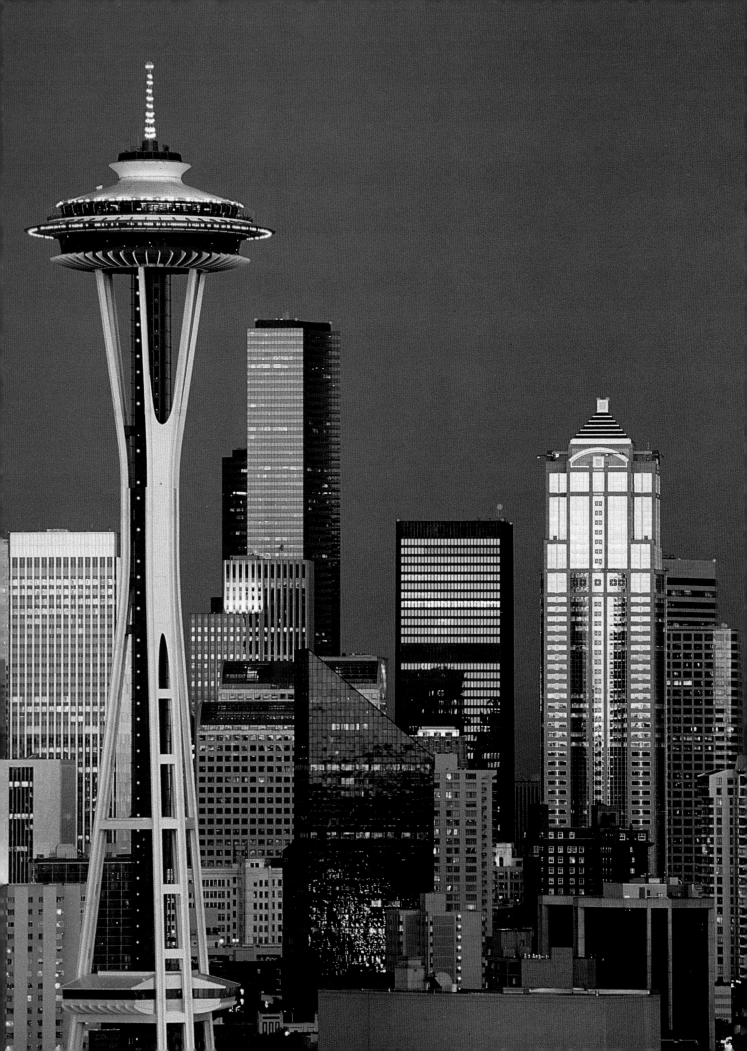